Salvador Dalí

Salvador Dalí

Life and Work

Frank Weyers

KÖNEMANN

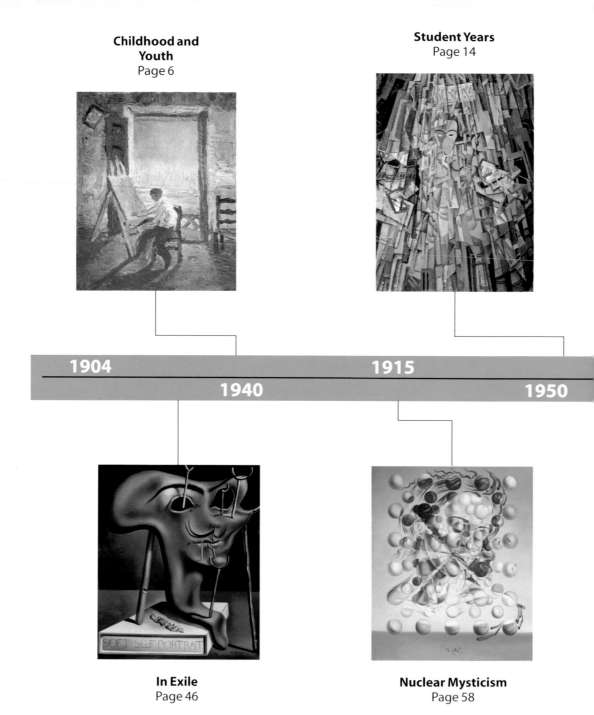

Childhood and Youth
Page 6

Student Years
Page 14

1904

1915

1940

1950

In Exile
Page 46

Nuclear Mysticism
Page 58

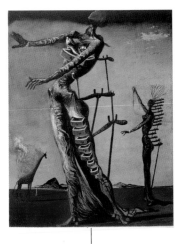
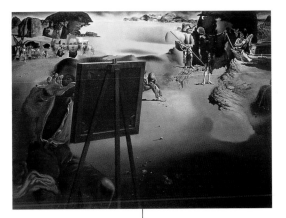

Childhood and Youth 1904–1920

Salvador Dalí's life and work are inseparably linked. Many events in his life produced an immediate result in his work, and numerous pictures can only be deciphered with the help of biographical facts. Dalí had his first drawing lesson at the age of ten, at the suggestion of the then celebrated Impressionist painter Ramon Pichot (1872–1925), who was a friend of Dalí's father. The lessons took place in El Muli de la Torre, a mill owned by the Pichot family, and here Dalí became familiar with Impressionist techniques. The painter later recounted that Pichot's pictures influenced him because they were his first contact with a non-academic style of art. Besides portraits, drawings, and pictures from this time feature mainly the landscape of his Catalan homeland, a subject which would constantly recur in his work.

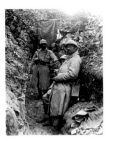

French soldiers, 1916

1905 Albert Einstein develops the theory of relativity.

1914 July crisis. First World War breaks out.

1914-15 Kasimir Malevich paints the *Black Square*.

1917 Duchamp shakes the art world with his ready-made *Fountain*, a urinal on a plinth.

1919 Prohibition Act passed in the USA.

Dalí at the age of four

1904 Salvador Felipe Jacinto Dalí born in Figueras.

1908 Birth of his sister Ana-Maria.

1914 Dalí becomes familiar with Impressionist painting. Goes to a private secondary school in Figueras.

1918 Dalí is taught drawing by Professor Juan Núñez at the municipal art school in Figueras. First exhibition of his works held in the municipal theater of Figueras.

Opposite:
Self-portrait in the Studio, ca. 1919
Oil on canvas
27 x 21 cm
Salvador Dalí Museum, St. Petersburg
(Florida)

Right:
Salvador Dalí, ca. 1909

Childhood

Salvador Felipe Jacinto Dalí was born on May 11, 1904 in Figueras, a small Spanish town close to the Mediterranean coast and the French border. His father was the local notary, an influential member of society in the small town, while his mother, Felipa Domenech Dalí, came from a distinguished bourgeois family in Barcelona. Dalí was born exactly nine months and ten days after the death of his brother, who did not even reach his third birthday. As the brother had borne the same Christian name, Dalí often felt like a sort of substitute son, although the premature death of the first child led the parents to take great care of, and indeed spoil, their second. At home, young Dalí played the part of a little

tyrant who had the whole house under his thumb, and quickly learnt to exercise considerable power over his parents. If he did not get his way, he was capable of impressive outbursts of rage.

The boy's upbringing was in the hands of the women of the house – his mother, grandmother, aunts, and nanny – but he also began to cross swords with his father. Dalí's father was both an authoritarian with conservative views and an atheist and freethinker who supported the independence of Catalonia from the Spanish state. His attempts to instill discipline in his son were met with extravagant and irrational behavior such as staged, endless fits of coughing at table.

Drawing was on the curriculum even in the boy's schooldays, and his works were first publicly exhibited in 1918 at the municipal theater of Figueras. The critics loved them. During this period, he was drawn not only to Impressionism but also to Cubism. In 1919, at the age of 15, he founded a newspaper for which

Don Salvador Dalí y Cusi, ca. 1904

Doña Felipa with her Sister Catalina (Tieta), ca. 1904

Dalí's father was considered an intelligent and educated man who could speak sensibly and entertainingly on almost any subject. He was interested in music, painting, politics, and of course his own subject law. As many of his friends belonged to the political and intellectual avant-garde, they were in a position to recognize and encourage young Salvador's talent. Dalí's mother Felipa Domenech married his father, who had just been appointed notary, in 1900. Her brother had a well-known bookstore in Barcelona that was a meeting place for writers and artists. With his excellent contacts in the art world, Dalí's uncle was a major influence in the artist's development. Dalí's aunt Catalina "Tieta" Domenech was unmarried and lived with the Dalís in Figueras.

Portrait of Lucia,
1918
Oil on canvas
43.5 x 33 cm
Privately owned

Dalí was ill when he painted this picture. Lucia was his nanny, and looked after him during this time. Dalí idolized the old woman, and as a child particularly loved the stories she read to him and his sister at bedtime. The picture shows the great artistic talent he already had at 14. The thoughtful color composition, three-dimensional modeling of the facial features and superb brushwork reveal an early gift for portraiture.

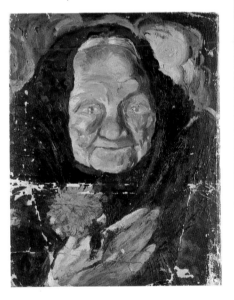

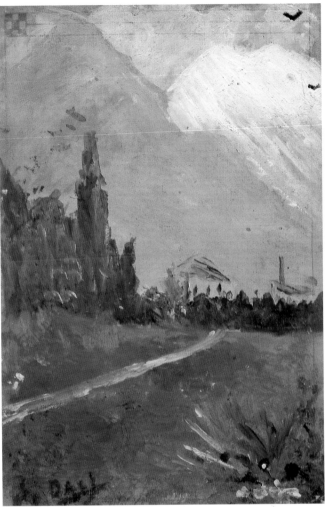

he wrote articles about works of great masters such as El Greco, Goya, Michelangelo, and Velázquez. He read Nietzsche, Kant, and Voltaire, and began to take an interest in psychology. Although he had achieved fairly indifferent results in his schoolwork, he got astonishingly good marks in his matriculation exam, so that there was no obstacle to him taking the entrance exam for art school.

Landscape (View of the Surroundings of Figueras), ca. 1910
Oil on card
14 x 9 cm
Private collection

Cadaqués

Salvador Dalí came from the Spanish province of Catalonia, nowadays an autonomous region within Spain. The six million Catalans have fought again and again for their independence from the central Spanish state and struggled to assert their own language, literature and culture. Like his father, Dalí was at first a passionate Catalan, but later developed into a supporter of the dictator Franco and an advocate of centralism.

Dalí's homeland, especially the landscape of the Plain of Ampurdán with his native town of Figueras, constitutes a constantly recurring subject in his work. Most of all, Dalí was fascinated by the coastal villages of Cadaqués and Port Lligat, with

Portrait of Hortensia, a Peasant Woman from Cadaqués, 1920
Oil on canvas
35 x 26 cm
Private collection

Below:
The Dalí family outside their house, posing on the rocks on the shore at Cadaqués, 1910

Six-year-old Salvador sits in front of his parents beside Tieta Catalina, who leans towards Ana-Maria, Dalí's small sister. In the white rocking chair sits his grandmother Mariana. At the top, on the left is the children's nanny Lucia.

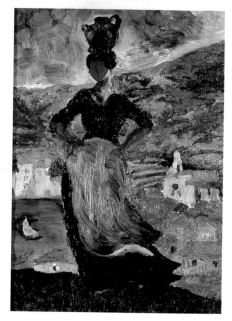

their steep cliffs and the unusual light effects that turn the sea in the bay from deep black to pale green, depending on the effect of the sun or moonlight. This part of the Catalan coast is plagued, both in summer and winter, by violent storms that lash the sea against the rocky coast. Over the centuries these storms have carved out bizarre rock formations in which it is possible to make out faces or animals. In this landscape, and its changing countenance during the course of the day, Dalí would find an important source of inspiration all his life.

In Cadaqués, which is only about 20 miles from Figueras, the Dalís owned a house where the family spent the summers. This fishing village is enclosed by high mountains, and looks out on a bay that offers a

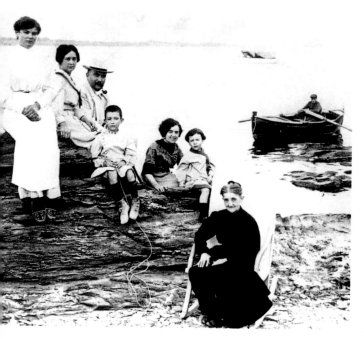

Ship (Trading Brig Drops Anchor in the Bay of Cadaqués),
ca. 1919
Oil on canvas
26 x 31 cm
Privately owned

The lively brushwork and shimmering chiaroscuro of the surface of the sea are indicative of Dalí's intensive preoccupation with Impressionism. Impressionists sought to capture the passing moment in their pictures, and catching the light effects enveloping the subject was critical. Dalí uses, as does Monet for example, small brushstrokes to catch the mood of evening, indicating that he knew absolutely how to imitate the Impressionist style. To practice his handling of Impressionist subject matter and painting techniques, Dalí used a trick. He had discovered that the crystal stopper of a carafe could be used like a kaleidoscope. If he looked through it, he had the impression of looking at an Impressionist painting.

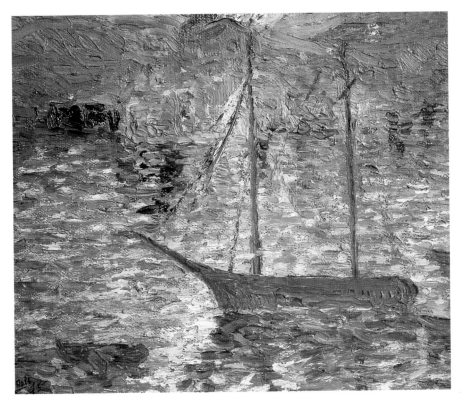

haven for vessels from seas that can be stormy even in summer. To the north looms Cap de Creus, a massive headland "where the mountains of the Pyrenees dive into the sea in a grandiose geological delirium," as Dalí himself once put it.

Here, together with his sister Ana-Maria, three years his junior, he went on excursions with the fisherman El-Beti, who could name every individual cliff and knew lots of the stories which had been handed down in the village from generation to generation.

On many summer evenings when the sea was less stormy, the Pichots, who were friends of the Dalí family, organized nocturnal musical concerts on the water or the clifftops. At great expense, a grand piano was placed in a boat or on the rocks for this purpose. When Dalí later painted such phenomena, they therefore came not just from his imagination but often referred back to specific childhood experiences.

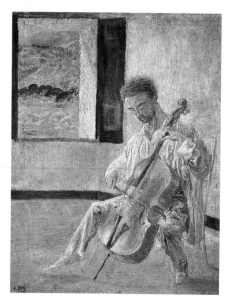

Portrait of the Cellist Ricardo Pichot, 1920
Oil on canvas
61.5 x 49 cm
Private collection

The picture shows Ricardo Pichot, a brother of the painter Ramon Pichot, playing the cello in a bare room bathed in the rosy light of the setting sun. Despite various weaknesses in the composition, the painting reveals the talent of the young Dalí in the coloration and brushwork.

Early Works

Momentous for Dalí's development as a painter was a stay at El Muli de la Torre in 1916, the Pichot family's mill near Figueras. There, Dalí discovered a worm-riddled door, on which he painted cherries using only three colors: vermilion for the bright parts, carmine red for the dark parts, and white for the highlights. He applied the colors directly from the tube, sticking real cherry stalks into the fresh paint.

Pepito Pichot, a brother of Ramon Pichot is supposed to have exclaimed on seeing the collage: "That shows real genius!" and so reinforced the

Self-portrait with Raphael's Neck,
1920–21
Oil on canvas
41.5 x 53 cm
Fundación Gala-Salvador Dalí, Figueras

There is more than a touch of arrogance and ebullient self-assurance in this self-portrait with the features of the great Italian painter Raphael. It is clear that Dalí considers painting his vocation and entertains lofty ambitions. Naturally the young artist targets the fame and genius of Raphael and he is not afraid to show it.

12-year-old's resolve to become a painter.

From autumn 1916, Dalí was given extra teaching at the Municipal Drawing School under Professor Núñez, who introduced the boy to the fundamentals of drawing and composition. Lasting six years, the tuition was of extraordinary importance for his artistic development. During this time, Dalí tried his hand particularly at an Impressionist style, combined with elements of Fauvism and traditional Catalan art.

Dalí had become familiar with Fauvist art, which principally meant the pictures of Matisse, from books and newspapers that he got through his uncle's bookstore in Barcelona. The bold color combinations in his *Self Portrait with Raphael's Neck* betoken appreciation of the Fauvists' demand that more importance be attached to pure color than form.

"This artist will be the talk of everyone!" prophesied established art critics in 1918 after seeing Dalí's exhibition at the municipal theater in Figueras, and confirmed that the artist, then just 14, had extraordinary talent. Besides a number of portraits, it was mainly the landscape around Cadaqués, which Dalí had captured in its often lyrical moods and all its beauty, that enchanted both critics and public alike.

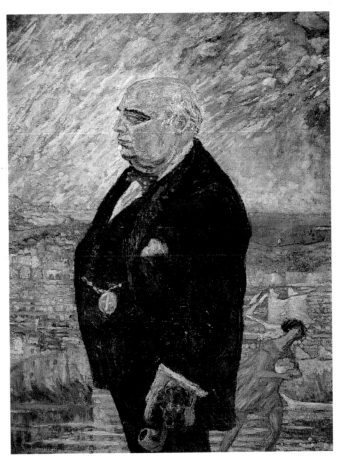

Portrait of My Father, 1920–21
Oil on canvas
90.5 x 66 cm
Fundación Gala-Salvador Dalí, Figueras

The imposing figure of the notary of Figueras stands proudly atop a hill overlooking Cadaqués and seems to take possession of the whole bay and its surroundings. Shown in profile, he looks severe, almost imperious. The black suit, stately fob and pipe in the left hand characterize the subject as a dignitary of high social standing. The portrait conveys the feeling of distance between the painter and sitter, which is presumably explained by the complex relationship between the strict father and pubescent son. A young girl – probably Dalí's sister – is shown running up the slope. The small, moving figure is in stark contrast to the statuesque silhouette of the father, and conveys a feeling of childish freedom and carefreeness.

Student Years 1921–1928

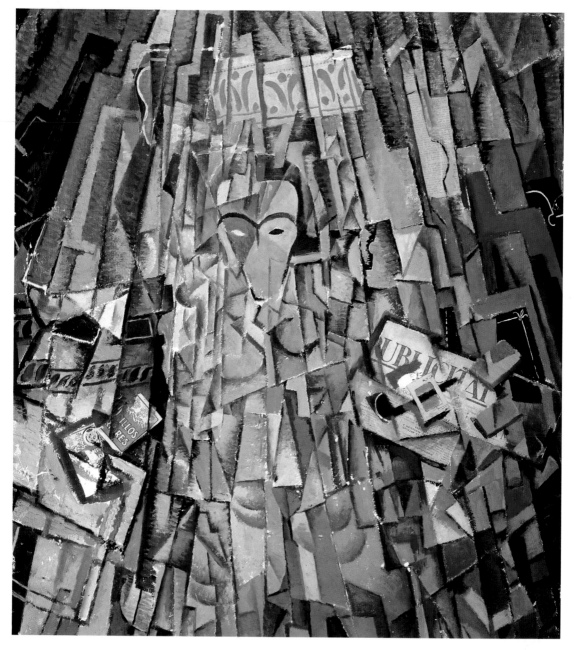

After matriculating, Dalí began studying art at the Royal Academy of Art in Madrid. The rebellious student had barely registered when he was expelled from school. He was held to be the ringleader of a student protest against the appointment of a supposedly conservative professor. Shortly after, the Dalmau gallery in Barcelona put on the first Dalí one-man show, which received outstanding reviews. In June 1926, Dalí had to leave the academy once more because he refused to sit the exams: convinced of his own talent, he declared the examiners were not adequately qualified to assess him. He therefore spent a lot of time in Figueras and Cadaqués, where he devoted himself intensively to his artistic studies. Nevertheless, the brief period in Madrid was decisive for his later life, as it was there that he became acquainted with Luis Buñuel and Federico García Lorca and made his first contact with Surrealism.

Charlie Chaplin, 1928

1920 Women's suffrage introduced in the USA.

1922 Treaty of Rapallo regulating German-Russian relations signed.

1923 *Time* magazine founded.

1924 André Breton publishes his *Surrealist Manifesto* (October).

1925 Walter Gropius establishes Bauhaus in Dessau.

1926 Fritz Lang films *Metropolis*.

Salvador Dalí ca. 1925

1921 Dalí's mother dies on February 6. Dalí sits entrance exam for Royal Academy of Arts in Madrid.

1923 Dalí excluded from classes for a year. *Cubist Self Portrait*.

1926 First trip to Paris. Visits Picasso. Expelled for good from art school.

1927 Dalí does military service.

1928 27th international exhibition of paintings in Pittsburgh. Dalí exhibits three paintings.

Opposite:
Cubist Self Portrait, 1923
Gouache and collage on card
104.9 x 74.2 cm
Museo Nacional Centro de Arte
Reina Sofía, Madrid

Right:
Dalí's class at art school in Madrid, 1923

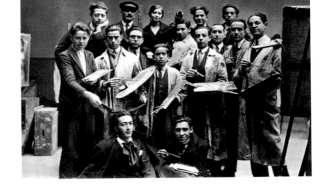

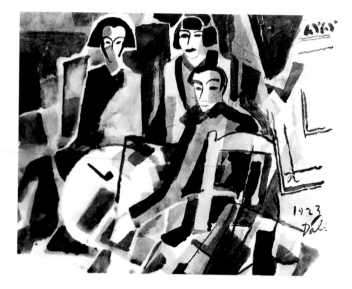

Madrid Friends

In Madrid, Dalí lived in the Residencia de Estudiantes, a hostel for upper-middle class students that was considered both modern and thoroughly receptive to the European avant-garde. A well-furnished library offered students the opportunity to inform themselves thoroughly about international trends in art. Best of all, many famous personalities of the day such as physicist Albert Einstein, writer H. G. Wells or composer Igor Stravinsky gave lectures there or performed their works.

Dalí spent his first spell in Madrid in complete seclusion while he devoted himself exclusively to his studies, but he soon came into contact with other students of the Residencia, including Luis Buñuel and Federico García Lorca. Dalí struck up a close friendship especially

Coffee House Scene in Madrid, 1923
Indian ink,
dimensions unknown
Privately owned

This sheet belongs to a series of Indian ink drawings and oil studies in which Dalí tried his hand at the flatness, formulaic composition and collage-type approach of the Dadaists. A similar schematic approach to the face also occurs in his famous *Cubist Self Portrait* (cf. page 14).

Federico García Lorca and Dalí, Cadaqués 1927.

with Lorca, with whom he often collaborated – and talked the night away. Lorca's *Ode to Salvador Dalí* indicates the intensity of the relationship, and led Dalí to suspect that the relationship meant more for the homosexual poet than mere friendship. Dalí felt uncommonly flattered, but was at the time sexually completely inexperienced and was terrified of being thought homosexual. Long after Lorca's death, the artist stressed time and again that there had never been any sexual contact between them. Nevertheless, photos from the period bear witness to an almost intimate familiarity between the two.

Together with friends at the Residencia, Dalí developed an indi-

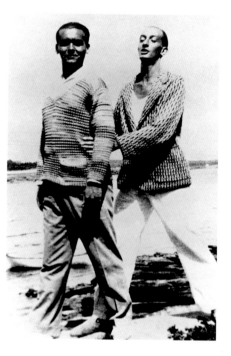

vidual terminology of signs and symbols which constantly recur in later works as well. One of the key words is *putrefacto* (putrefaction), which is often represented in Dalí's pictures by a decaying donkey or ants devouring a corpse. Dalí had already used the word with his school friends. It was a term of abuse for the hated *grand bourgeois* establishment and conservative society.

The painter's friendship with Lorca lasted until approximately 1928. Gradually he came to regard the way the poet allowed folklore and regional elements to invade his literature as retrograde. Also, he began to dislike the poet's romantic feelings towards him, and increasingly kept his distance.

During the Spanish Civil War, Lorca fought on the side of the Republicans, and in 1936 was executed by Franco's Fascists. Shortly before this, Dalí had resumed contact with his old friend, and was profoundly shocked by his death.

Portrait of Luis Buñuel, 1924
Oil on canvas
70 x 60 cm
Museo Nacional Centro de Arte Reina Sofía, Madrid

The son of a rich businessman from Aragon, Buñuel had lived in the Residencia since 1917. After initially studying engineering, he changed to entomology and finally history. A gregarious member of several intellectual groups preaching avant-garde art and literature, he introduced Dalí to Madrid's nightlife. Dalí's portrait shows his deep admiration for his friend's decisiveness and intelligence, and captures Luis Buñuel's condescending maturity precisely.

But above all I sing a way of thinking we share, that unites us in the dark and the golden hours. Not art is the light that blinds our eyes. First it's love, friendship or even fencing.

Federico García Lorca

Painting Experiments

During his school days, Dalí had been interested above all in Impressionism. His student period in Madrid marked a phase when he absorbed the most diverse artistic styles at such a terrific rate that he aroused the admiration of many fellow students, particularly as he was always able to preserve something individual and did not merely imitate. Dadaism briefly appealed because of its collage-like method of composition; in a few Futurist pictures, he explored the problem of depicting movement. He was intrigued by the use of different perspectives in a single painting, as evidenced in Cubist pictures by Juan Gris and Pablo Picasso. Later it was mainly Picasso's Neoclassical works that provided important stimuli for Dalí's stylistic development, on the way towards a virtually photo-realistic technique.

All these painting experiments went on in parallel, and Dalí often worked simultaneously on pictures that were formally highly different to each other. He was still looking for his own, personal style.

Towards the end of 1924, there ensued a period of an unusually mature and serene painting that displayed a tendency towards New Objectivity. His favorite model of the time was his sister Ana-Maria, whom the painter presented in the most diverse views, but most often in rear view. Precise contours, cool coloration, and three-dimensional modeling – characteristics of the style of Classicist painter Ingres and

Poster for a Dalí exhibition at the Dalmau Gallery in Barcelona, 1925

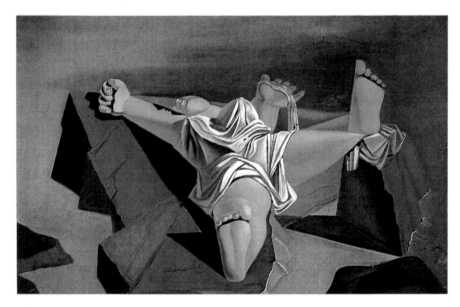

Figure between the Cliffs (Sleeping Woman), 1926
Oil on plywood
27 x 41 cm
Salvador Dalí Museum, St. Petersburg (Florida)

The prostrate figure has been interpreted as Venus or Lust. The woman's sex is hidden by the shirt, but is reproduced in the shadow produced by the folds between the spread legs.

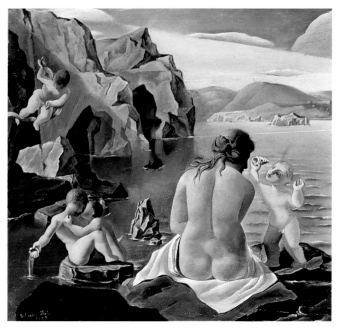

the Neoclassicism of Picasso – are what distinguish these works.

From about 1926, Dalí painted in an exaggeratedly sharp, almost photo-realistic style, which the artist tried out at the same time as the other styles. In his paintings of the period, Dalí proved that he was now a complete master of the painting techniques of old masters. It was this perfection in reproducing his subject that he later exploited in order to represent the most peculiar motifs from his irrational daydreams and nightmares as reality.

Influenced by the painting of Joan Miró (who visited him in Cadaqués in 1926), Giorgio de Chirico, and Yves Tanguy, Dalí began to place motifs in free association in apparently unreal landscapes, whose sole constant fea-

ture was the cliffs of the Costa Brava. Fragments of bodies, faces, and limbs, plus the corpses of asses and skeletons of birds as motifs representing the philosophy of putrefaction, populate these pictures and can often be interpreted biographically. But more than anything, these pictures are an expression of Dali striving to create works that represent a "handmade color photography of concrete irrationality," as he formulated it in writing in 1927. They mark the transition to Dalí's Surrealistic period, which began in 1929.

Un Chien Andalou

A slender cloud passes across the moon in the night sky, and the scene fades into the eye of a young woman, which is sliced with a razor. This opening sequence of the film made jointly by Luis Buñuel and Salvador Dalí is among the most celebrated and impressive scenes in film history.

In 1928, Buñuel came to Dalí proposing they make a film. The painter was enthusiastic about Buñuel's project but not about the screenplay, and so wrote a script of his own. Buñuel perceived that Dalí's proposals were better, and they met in Figueras to work up the idea. The rules underlying the film were simple: pictorial ideas and sequences should follow no logic; only the irrational and the surprising were permitted. Shooting in Paris took two weeks. How far Dalí himself, who has a cameo in the film as a monk, took part in the filming is not known.

In June 1929, the film was first shown in a private screening under the title of *Un chien andalou* (The Andalusian Dog). Among those present were architect Le Corbusier, Picasso, and leading Surrealist André Breton. Breton immediately recognized the immense talent Dalí and Buñuel had shown, and described the work as the first Surrealist film ever. Numerous reviews lauded it as a turning point in the history of the cinema and masterpiece of Surrealism.

Buñuel and Dalí's work occupies an important position in film history inasmuch as it first carried over into

Film sequences from *Un chien andalou*, 1929

The sliced eye was in fact that of a cow. Both Buñuel and Dalí claimed to have had the initial idea for this famous scene. Generally, authorship of individual sequences is difficult to establish. The hand that turns into a swarm of ants is among the motifs that can definitely be attributed to Dalí. Ants constantly recur in his pictures and are a component in his putrefaction philosophy.

Un chien andalou was a film about puberty and death, with which I stabbed intellectual, elegant Paris with the whole reality and entire sharpness of the Iberian dagger.

Salvador Dalí

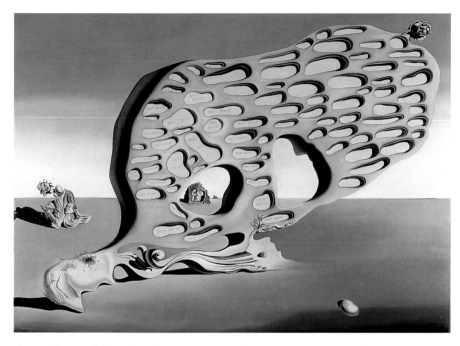

The Enigma of Desire – My Mother, My Mother, My Mother, 1929
Oil on canvas
110 x 150.7 cm
Staatsgalerie moderner Kunst, Munich

The rock springing from a head in profile carries the inscription "Ma Mère" in its cavities and niches. The head recurs in similar shape in many works of Dalí, but usually develops into erotic fantasies. The title of the picture refers to the Oedipus complex postulated in Freud's psycho-analytical theories and describes the fear of castration. This fear is suggested by the intertwined figures in the background, one of which holds a knife. The motif of the grasshopper nestling against the couple is intended as a symbol of fear, and refers back to the painter's childhood experiences. Even as a small child Dalí had a horror of grasshoppers and had hysterical fits when one looked liked jumping on him.

the medium of film the design principle of a free association of visual and linguistic motifs demanded in Breton's *First Surrealist Manifesto*. Straightaway in the first take the audience is thrown into a state of shock, which does not let up for a moment: terror, human suffering and putrefaction mix with macabre comedy and juicy everyday scenes. Montage techniques and the inter-meshing of motifs recall the "auto-matic writing" technique of the Surrealists, which was supposed to bring unconscious and irrational thoughts to the surface, and they are still considered a milestone in terms of 20th century film aesthetics. The narrative structure, which causes apparently sensible phenomena to turn absurd and at the same time hints at a more profound sense in their absurdity, was intended as a challenge to the public's imagination, and had a corresponding success.

After filming was over, Dalí returned to Spain and again devoted himself exclusively to his painting, because his first one-man show in Paris lay ahead of him. He was not present at the film première in October, and did not return to Paris until November.

Surrealism

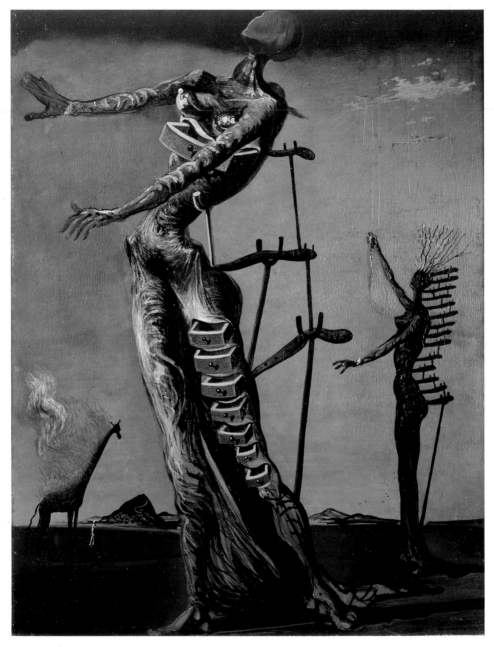

The time between 1929 and the outbreak of war in Europe was the most productive and important period in Dalí's oeuvre. He met his future wife Gala Eluard, joined the Surrealist group, and developed his "critical paranoia" method, an artistic process he remained bound to all his life and which is considered one of the most important contributions to Surrealism. Dalí wrote numerous essays in Surrealist publications to explain his ideas and realizations of them, because he had now found a wholly personal painting style of his own that was to make him famous world-wide. His best-known works date from this period, and he finally reaped the financial success he longed for: contracts with patrons and dealers secured him a regular income and thus the economic basis for his artistic output.

Hitler at a rally, 1934

Dalí, 1929

1929 Wall Street crash triggers worldwide economic crisis.

1931 Auguste Picard is first to venture into the stratosphere.

1932 Aldous Huxley's novel *Brave New World* is published.

1933 President Hindenburg appoints Hitler chancellor.

1936 Carl Orff composes *Carmina Burana*.

1929 Dalí paints *Dismal Sport*. Surrealists visit Dalí in Cadaqués. Dalí meets Gala Eluard. Première of *Un chien andalou*.

1930 Dalí buys a fisherman's hut in Port Lligat. Buñuel and Dalí film the *Age of Gold*, banned a few months later.

1931 The first Surrealist "objects" are made. *The Persistence of Memory*.

1933 Illustrations made for Comte de Lautréamont's *The Songs of Maldoror*. Paints *Enigma of William Tell*. First exhibition in New York.

1934 First visit to USA.

1935 Dalí publishes *The Conquest of the Irrational*.

Opposite:
Burning Giraffe, 1936–37
Oil on wood
35 x 27 cm
Kunstmuseum, Basel

Right:
Lobster Telephone (Aphrodisiac Telephone), 1936
Telephone, plaster
15 x 30 x 17 cm
Museum Boijmans van Beuningen, Rotterdam

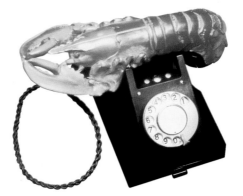

Meeting Gala

In spring 1929 Dalí became acquainted with the French poet Paul Eluard through the mediation of his art dealer Camille Goemans. Eluard promised to visit him in the summer in Cadaqués. That summer, the artist painted his famous picture *Dismal Sport* (see page 33), which would shock even his Surrealist friends with its unsparing depiction of excrement. During this period, Dalí obviously tried particularly hard to escape the influence of his authoritarian father, and displayed great insecurity in his dealings with other people. His condition took on hysterical traits. His pictures now featured his real nightmares and were peopled with disturbing figures.

When Eluard arrived in Cadaqués with his wife Gala and their daughter Cécile, Dalí felt himself immediately attracted to Gala. His hysteria became so bad that his friends began to worry and asked Gala to look after him. Dalí became even more eccentric, to attract attention. He shaved his armpits and painted them blue, cut up his shirt, smeared himself with goat dung and fish glue and stuck a red geranium over his ear. But when he saw Gala, he was only shaken by insane laughter, at which she took him by the hand and tried to calm him by promising never to leave him again. It soon became clear that Gala and Dalí were inseparable, and when Eluard gave his wife an ultimatum to go back to Paris with him, she decided to stay with Dalí.

Gala was about ten years older than Dalí and came from Russia. Paul Eluard had met her in a sanitarium in Switzerland and married her in Paris in 1916. Through her husband she had come into contact with the Surrealists and many other avant-garde artists, including the painter Max Ernst from Brühl near Cologne,

Portrait of Gala with Two Lamb Cutlets in Equilibrium on Her Shoulder, 1933
Oil on olive wood
6 x 8 cm
Fundación Gala-Salvador Dalí, Figueras

Edible motifs are metaphors of recognition in Dalí: the eater assimilates the unfamiliar. The Surrealist principle of free association underlies the picture, Dalí associate his passion for cutlets and his passion for Gala.

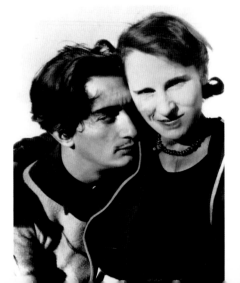

Gala and Dalí, 1932

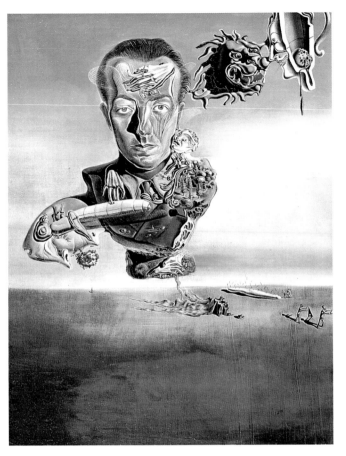

Portrait of Paul Eluard, 1929
Oil on card
33 x 25 cm
Formerly Gala and Salvador Dalí collection

Paul Eluard was among the leading French poets. This picture of him by Dalí dates back to the summer when the painter met Gala and began a relationship with her. The poet floats, dressed in jacket and tie, as a bust over the expanse of the Plain of Ampurdán. Arranged around him are the symbols which crop up in virtually all Dalí's works of this period: grasshoppers, lion and monster heads, ants and hands. In the context of the hands, which stand for masturbation and thus an "impure" act, these motifs of fear illustrate the unstable psychic state of the painter.

Gala's relationship with Dalí seems to have had no adverse effect on the friendship between the two men. Gala remained a close friend of Eluard, who behaved as magnanimously as in the Max Ernst affair. The portrait proves the high esteem that the painter had for Eluard: the symbols of Dalí's obsessions and fears that surround the bust of the poet create a very personal and familiar connection between the men who loved the same woman.

with whom the sexually liberated Gala had had a relationship.

Gala had a sharp understanding of art, which was much appreciated by the Surrealists. Her importance as an adviser and muse was acknowledged by Max Ernst in a painting called *Meeting of Friends* (1922), in which she appears as the only non-creatively active person among the group of painters, poets, and philosophers. In Gala, Dalí found an ideal partner, without whom his hysteria might have become morbid. As the artist stressed again and again in his writings, Gala embodied not only the much longed-for, perfect love, but also a vital therapist.

The Surrealists

After Georges Bataille published a long article about the painting *Dismal Sport* in 1929 (see page 33), the Surrealists began to take Dalí seriously as an artist. The new member of the group immediately set about helping André Breton establish a periodical called *Surrealism in the Service of Revolution*, designed the cover picture for the Second Surrealist Manifesto, and wrote several articles and essays for Surrealist publications.

The theory on which Surrealism was based was formulated by Breton in 1924, in his first *Surrealist Manifesto*. For the members of the group, which consisted predominantly of writers, the source of all art was the subconscious mind and dreams, with the help of which the obligations of social conventions and common sense would be overcome. Great interest was aroused among intellectuals especially by the

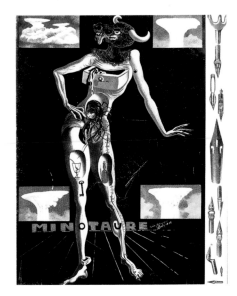

Cover page for *Minotaure* magazine, designed by Dalí, 1936

Between 1932 and 1933, the leading publisher Albert Skira published twelve issues of this luxuriously designed and printed periodical. Every cover was designed by a different artist, and Surrealist poets published their best texts in it. The influence and quality of *Minotaure* was never surpassed.

The Surrealist group in Paris, 1930

From left to right: Tristan Tzara, Paul Eluard, André Breton, Hans Arp, Salvador Dalí, Yves Tanguy, Max Ernst, René Crevel, Man Ray.

Surrealistic method of *écriture automatique* (automatic writing), which demanded that texts be written without using the conscious mind and pictures be painted purely intuitively, recording and setting down images from dreams or the subconscious.

The group had developed from Parisian Dadaism, a movement that

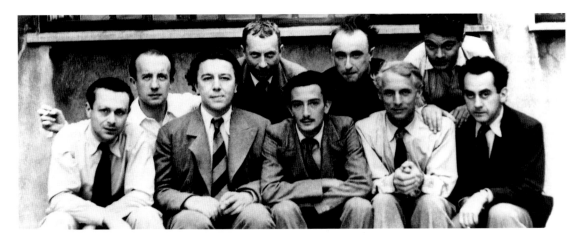

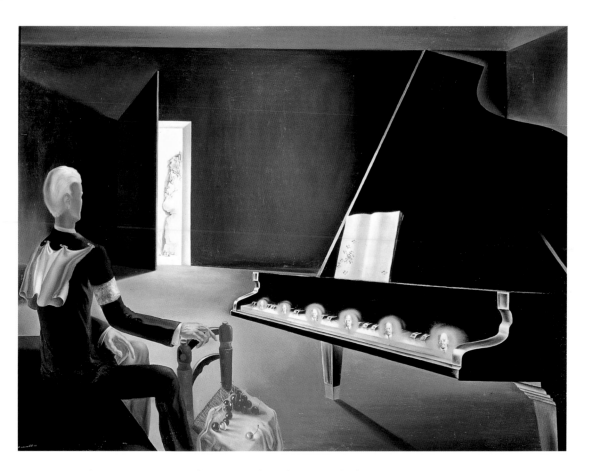

was opposed to traditional art forms but at the same time rejected anarchic, destructive urges. It was much more interested in the search for a new social utopia, orienting itself on the ideology of Communism. It thought it could achieve its socio-political objectives by following Freud's psychoanalysis and revealing our subconscious desires, thereby helping to liberate people. Dalí had been familiar with the writings and works of both the Surrealists and Freud since his student days in Madrid.

When he joined the movement, it had already passed its peak, but it was kept alive for a while by the inventiveness of the painter and his development of the "critical paranoia" method (see pages 32–33).

Partial Hallucination, Six Appearances of Lenin on a Grand Piano, 1931
Oil on canvas
114 x 146 cm
Musée National d'Art Moderne, Centre Georges Pompidou, Paris

In this picture, Dalí was alluding to the Surrealist veneration of the Communist leader.

The Persistence of Memory

"Soft clocks" are nothing more than the soft, extravagant, unique and critically paranoiac camembert of space and time.

Salvador Dalí

Against a background of the cliffs of Cap de Creus an amoeba-like head lies in the landscape, similar in form to the one which appears in *Dismal Sport* (see page 33) and *The Great Masturbator*. A fob watch droops over this head in profile with its long eyelashes, while to the left of the figure we recognize a clay-colored plinth, over the edge of which another timepiece has "melted". On the far edge of the plinth stands a dead tree with another soft watch draped over its single branch. In contrast to these floppy timepieces is a solid, closed fob watch on the front part of the plinth, with numerous ants crawling over it. They and the fly that sits on the light blue, apparently water-filled dial constitute the only living things in this dismal, melancholic painting. Each timepiece shows a different time, because in Dalí's dream world linear, steadily passing time has no importance. Our past is stored in our memory.

Yet the timepieces melt, and even the solid clock is covered with ants, which in Dalí are a symbol for putrefaction, i.e. death. Objects made by human hands are thus shown to be transitory in Dalí's picture; only the "hard" motif of landscape, the cliffs in the background, which are therefore bathed in a bright light, having permanence. That is where the true persistence of memory lies. The content of the picture goes beyond that just described, however. Dalí's soft clocks were described by him as symbols of the four-dimensional space-time continuum of the theory of relativity. The theory demonstrated that each body has an innate time of its own that is dependent on its movement and its state of energy, not on time measured by clocks, as clock time adapts to energy conditions. In comparison with the eternity of the landscape of Cap de Creus, the purely technical measurement of time is ultimately without value or importance. The idea for this picture came to Dalí after an evening meal while he was gazing at the remains of a runny camembert. He suddenly projected its soft forms into the empty landscape of the picture he was working on just then. When Gala saw the picture for the first time, she is supposed to have exclaimed: "No-one who sees that will ever forget it." The work was exhibited at

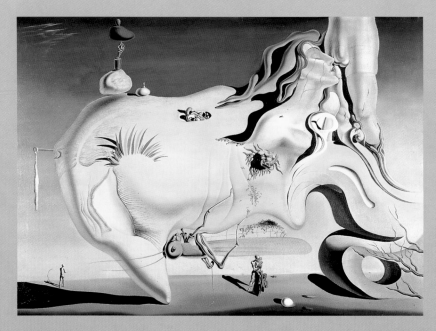

The Great Masturbator,
1929
Oil on canvas
110 x 150 cm
Museo Nacional Centro de
Arte Reina Sofía, Madrid

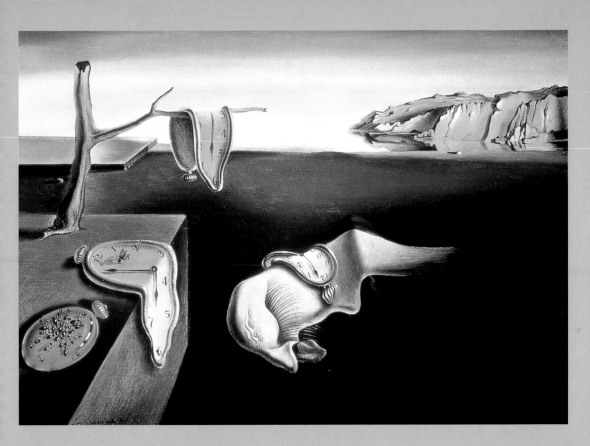

the Julien Levy Gallery in New York in early 1932, and represents the beginning of Dalí's career in the USA. *Soft Clocks* have meanwhile become a symbol for Dalí and his work as a whole. Not only is the work among his masterpieces; it is one of the most memorable paintings of the whole twentieth century.

The Persistence of Memory (also: The Soft Watches, or: Time Melting Away), 1931
Oil on canvas
24 x 33 cm
Museum of Modern Art, New York

Disintegration of the Persistence of Memory, 1952–54
Oil on canvas
25 x 33 cm
Salvador Dalí Museum, St. Petersburg (Florida)

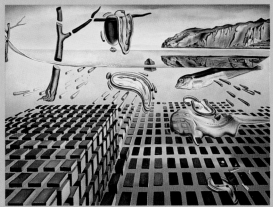

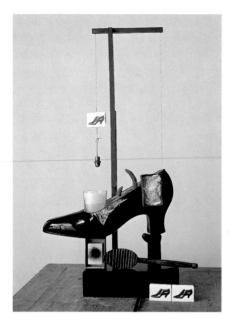

The Surrealist Object

Not until painters such as Dalí or René Magritte discovered the surreal in the real and depicted it in their pictures was the way prepared for producing "surreal objects with a symbolic function," as Dalí called them. Marcel Duchamp had already shown the way with his ready-mades by placing prefabricated everyday objects such as bicycle wheels and bottle rack on stands and calling them art. Unlike traditional sculpture, these objects contained no personal mark of the artist and eluded his aesthetic intervention. But the Surrealists wanted more. They gave their "objects" made up of everyday articles a more far-reaching function

The Shoe – Surrealist Object with Symbolic Function, 1932
Assemblage of various materials
48 x 24 x 14 cm
Destroyed (1974 reconstruction, privately owned)

A cube of sugar with the picture of a shoe on it hangs over a glass of milk beside a woman's shoe. The object is completed by various extras such as pubic hair and an erotic photo. The mechanism provides for the sugar to fall into the milk and dissolve in the fluid along with the picture of the shoe on it. This illustrates the difference existing between a real article and its image.

Gala with the shoe hat made by Elsa Schiaparelli, 1936

The French fashion designer Elsa Schiaparelli created this original hat from drawings provided by Dalí. The artist wrote of his delight in shoes: "Shoes are the objects charged with the most realistic forces." As a hat, Dalí liberated the shoe from these forces.

resulting from chance, the subconscious mind, dreams, and delusions, and therefore enriched their works quite deliberately with additional symbolic content. In this way, they would be psychologized, eroticized, and metaphorically charged. Many of these "objects" are reckoned among the movement's most original creations.

The first Surrealistic objects date from the end of 1931, when Breton and Dalí appealed for such works to be produced, to intensify their group work. At the same time, Dalí published an article analyzing the formal aspects of the new art form. Objects with symbolic meaning were not suitable for mechanical operation, but were in fact based on pictures and fantasies that manifested themselves in unconscious actions, and in Dalí were above all erotic in character. Dalí imagined that they would inundate the world and with their uselessness undermine social conventions.

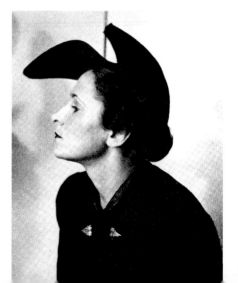

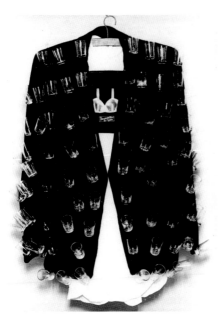

Aphrodisiac-jacket, 1936
Tuxedo with liqueur glasses, shirt, and dickey on a clothes hanger
77 x 57 cm
Destroyed

According to Dalí, the little glasses should contain peppermint liqueur, to which a strongly eroticizing effect was attributed. The artist thought the jacket was suitable mainly for excursions on still evenings, though the wearer would have to be carried by car very slowly so the peppermint liqueur did not get spilt.

Retrospective female bust, 1933
Assemblage of various materials
54 x 45 x 35 cm
Privately owned

The Surrealist "object" extended the traditional concept of sculpture in that the artist worked without formal rules and could only pursue his own associations. If some of Dalí's objects made a great impression on the public and fellow artists, the number of artistically valuable works is nonetheless small. Though in the following years Dalí wrote many theoretical essays classifying Surrealist objects into different genres, the *Aphrodisiac Jacket* dating from 1936 brought this phase in Dalí's work to an end.

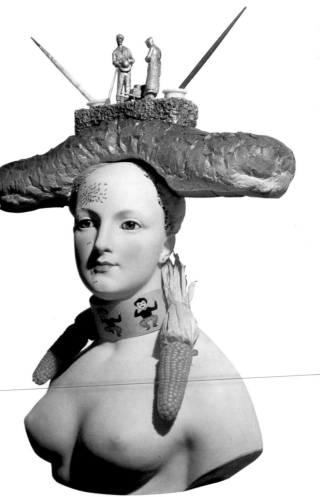

Dalí's Delusion

The only difference between a madman and me is that I am not mad.

Salvador Dalí

Dalí's most important contribution to Surrealism was the development of "critical paranoia", that is a systematic misinterpretation of reality. By means of a process of hallucination inspired by Freud's investigations of the interpretation of dreams, the artist sought to alter his perception of reality. Freud had discovered that, under hypnosis, patients recalled repressed traumatic experiences. Bringing these to the surface could produce an alleviation of psychic disorders. The doctor thus emphasized the importance of dreams and spontaneous free associations in order to bring memories and experiences to light. Dalí now expanded the artistic free association technique developed by the Surrealists, "automatism," to the effect that he quite consciously translated dream images he had seen into pictures. This procedure meant not censorship of the subconscious images but their translation into real paintings, the result being "handmade photographs", to use the artist's term. To work on these pictures he used "critical paranoia", whereby he initially tried to objectivize and systematize purely subjective delusions and the very personal elements of the dream, and during the creative process held the dream in a kind of waking state. While Surrealist automatism revealed a new and different reality, Dalí explored and organized this other reality and thereby enabled the understanding of it. The painting *Dismal Sport*, dating from 1929, is an early example of Dalí's artistic design principle, which began Dalí's connection with Surrealist circles. The painting has a programmatic character, because Dalí demanded that there should be no moral taboos in Surrealist painting. Although Dalí's view was wholly within the spirit of the movement, other members of the group, and in particular Breton, were horrified by the representation of the figure wearing feces-soiled trousers in the foreground. In his detailed psychoanalytical interpretation of the

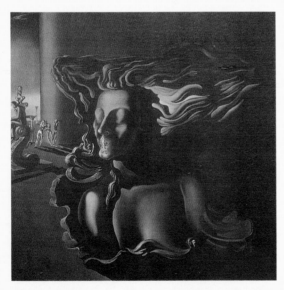

The Dream, 1931
Oil on canvas
100 x 100 cm
Privately owned

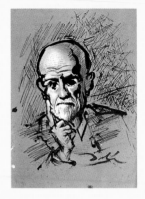

Portrait of Sigmund Freud, 1937
Indian ink and gouache on gray ground
35 x 25 cm
Privately owned

painting in 1929, Georges Bataille saw four basic elements depicted in the painting: castration, expressed through the disunity of the central figure; the subject's desire, illustrated in the rising elements in the upper half; the soiled subject, which is escaping castration by objectionable behavior, represented in the figure with the soiled trousers; and the poetic excessiveness of the shameful behavior, personified in the figure on the left-hand side of the picture. Bataille thus interpreted the picture as an expression of Dalí's guilt and inferiority complexes.

Many of the delusionary pictorial elements have acquired symbolic meaning thanks to Dalí's efforts at objectivization and systematization. The ants stand for putrefaction, the outsize hand of a male

Dismal Sport (also: Disastrous Game), 1929
Oil and collage on card
44.4 x 30.3 cm
Privately owned

figure for masturbation, grasshoppers for phobias from Dalí's childhood days, the trousers smeared with excrement for shame and sexual inhibitions. Dalí's texts contain many references to the meanings of these motifs, though they were not rigidly encoded but redefined over time. Despite the many difficulties that André Breton encountered with the extravagant personality of Salvador Dalí, he acknowledged the painter's achievement for the movement: "With his critical paranoia, Dalí gave Surrealism an instrument of prime quality that was immediately applicable to a range of things such as painting, poetry, the cinema, sculpture, art history, and occasionally even every kind of exegesis." This achievement is still undisputed by art historians of the twentieth century.

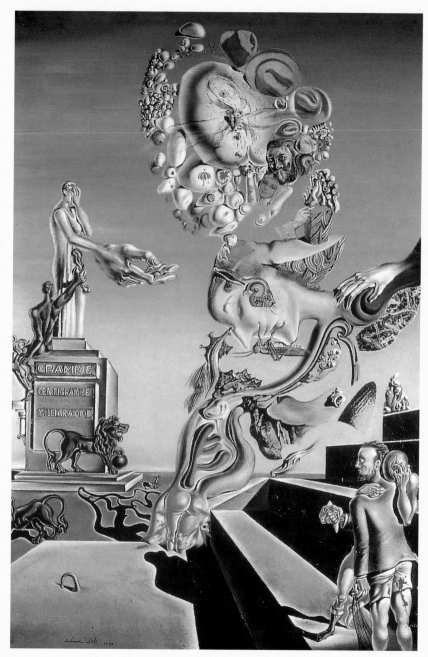

The Breach with André Breton

At the beginning of the 1930s, Dalí gradually distanced himself from the left-wing political ideals of the Surrealists. In 1933 he painted a controversial portrait of Lenin, and when he finally showed a swastika in a painting, the first great showdown ensued. Outraged by the pictures, Breton suggested the exclusion of Dalí from the Surrealist group. On February 5, 1934, a "trial" took place at which Dalí defended himself in Surrealist fashion: he said he had composed his Hitler and Lenin from dreams, and his interest in the German dictator was non-political and purely artistic in nature. All taboos should be proscribed, otherwise Breton might just as well give him a list of subjects he would be allowed to paint.

During the session, Dalí had a medical thermometer in his mouth and simulated flu. While he was talking, he took off his clothes one item at a time, finally concluding his defense with bare torso and the sentence: "And if I dream tonight that the two of us love each other, tomorrow morning I will paint our finest intercourse positions in the greatest of detail." His authority undermined by this performance, Breton had to drop the accusations against Dalí, but the deep breach that the affair occasioned soon led to the end of the artistic and personal friendship.

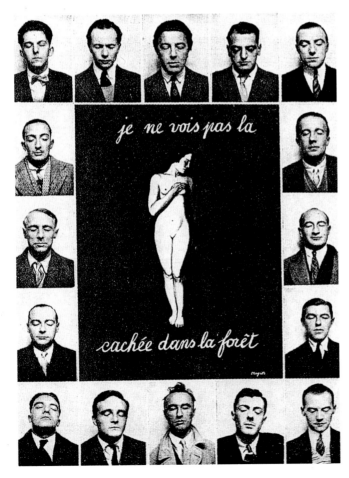

je ne vois pas la

cachée dans la forêt

René Magritte
I cannot see the woman hidden in the wood, 1929
Photo-montage for *The Surrealist Revolution, No. 12*

From left to right, clockwise: Maxime Alexandre, Louis Aragon, André Breton, Luis Buñuel, Jean Caupenne, Paul Eluard, Marcel Fourier, René Magritte, Albert Valentin, André Thirion, Yves Tanguy, Georges Sadoul, Paul Nougé, Camille Goemans, Max Ernst, Salvador Dalí.

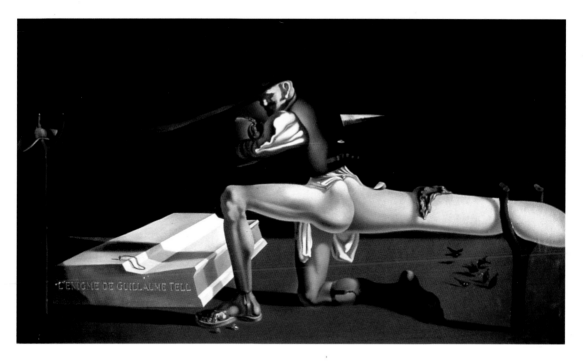

The Enigma of William Tell, 1933
Oil on canvas
201.5 x 346 cm
Moderna Museet,
Stockholm

The portrait of William Tell visibly carries the features of Lenin, an allusion to his exile in Switzerland. Lenin-Tell's right buttock has developed into a kind of gross excrescence that resembles a phallus; being soft, it requires a crutch to support it. Overall, it is longer than the figure's upper body. Dalí wrote of this work that the chunks of meat on the child's head – instead of the apple – and on the extended buttock of the father were an expression of the latter's cannibalistic desires to eat his child. Besides depicting his fears of impotence, the painter wanted to show his fear of his father, with whom he had finally fallen out after setting up a joint household with a married woman. The threatening situation in which Gala is portrayed in the picture declares the same thing: she sits as tiny as can be in a nutshell directly beside the giant foot of William Tell. Breton was so horrified by this picture of Lenin that he tried to destroy the picture at an exhibition , but it was hung so high that he could not reach it.

There was a censorship there that was governed by reason, aesthetics, and morals, and was characterized by Breton's taste or pure arbitrariness.

Salvador Dalí

The Rain Taxi

This object was specially designed for the International Surrealist Exhibition at the Galeries des Beaux-Arts in Paris.

Visions of War

1934–1939

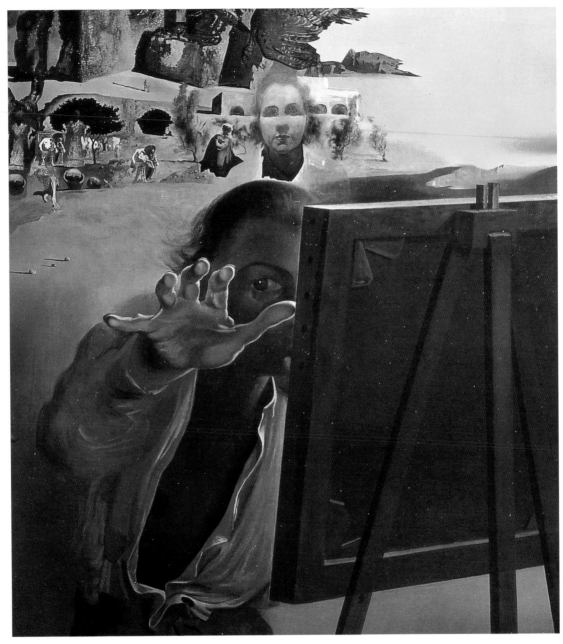

The period from 1936 to 1939 was overshadowed by political events in Europe. When the Spanish Civil War broke out in 1936, Dalí happened to be in London. Because of the political situation, he was only able to return home for two brief visits before leaving in 1940 for the USA and eight years in exile.

Dalí's paintings now displayed a stylistic assurance and maturity that gained him wide recognition both in Europe and the USA. Even before the outbreak of the Civil War, he produced a series of pictures that foresaw the horrors of the approaching war, and in other works as well Dalí made explicit reference to the current political situation in Europe. His best picture-puzzles – painted puzzles in which the viewer can see changing motifs depicted depending on his own powers of imagination – date from this time.

Spanish Civil War, 1936

Dalí in 1939

1934 USSR admitted to League of Nations.

1935 First subway in Moscow.

1936 Spanish Civil War breaks out, ending only in 1939 with Franco's victory.

1937 The Nazis present an exhibition of Degenerate Art. Eugenio Pacelli is elected as Pope Pius XII.

1939 Second World War breaks out.

1936 *Soft Construction with Boiled Beans – Premonition of the Civil War*. Dalí takes part in the exhibition of Fantastic Art, Dada, and Surrealism at the Museum of Modern Art in New York.

1937 Dalí paints *The Metamorphosis of Narcissus* and publishes a poem of the same name. He goes to Italy to escape Civil War.

1938 *Rain Taxi*. Gala and Dalí leave Italy because of the Munich crisis.

1939 Journeys to Bordeaux to escape mobilization.

Opposite:
African Impressions, 1938
(detail)
Oil on canvas
91.5 x 117.5 cm
Museum Boijmans van Beuningen, Rotterdam

Right:
Freud's Polymorphous Pervert (also: The Bulgarian Child Eating a Rat), 1939
Gouache on photography
40 x 35 cm
Privately owned

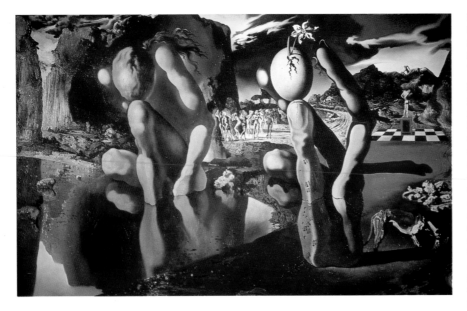

Metamorphosis of Narcissus, 1937
Oil on canvas
50.8 x 78.3 cm
Tate Modern, London

Dalí wrote a long poem for this painting setting out his version of the myth of Narcissus and referring to the organic cycle of death, disintegration, and rebirth. In the attitude and lighting of the limbs there is clearly a great similarity between this picture and the *Narcissus* by Caravaggio. In Dalí, the figure of Narcissus is reflected not only in the surface of the water but also in the double image of a bony hand.

Farewell to Port Lligat

In 1930 Dalí and Gala had bought a tiny fisherman's hut, no more than 16 square meters in area, in the bay of Port Lligat. With the money from the sale of pictures they were able to gradually enlarge the cottage in the early 1930s by constantly adding extensions, until it became a labyrinthine complex with steps, narrow corridors, and secret places. Every summer they retired here from Paris so that Dalí could work in total seclusion. Their last prolonged stay in this inspirational and artistically productive place was during the spring of 1936.

When civil war broke out in July, the Dalís were visiting their friend and patron Edward James in London. In Paris a little while later, they learnt of the murder of Dalí's friend from the 1920s, Federico García Lorca, which shocked Dalí profoundly. As the son of solid middle-class parents, the painter was

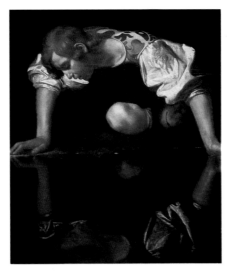

Caravaggio
Narcissus, 1596–1598
Oil on canvas
75 x 68 cm
Galeria Nationale d'Arte Antica, Rome

According to the myth, Narcissus spurned the affection of the nymph Echo and as a punishment instigated by Aphrodite fell in love with himself in his reflection in a well. To redeem him from his sufferings, the goddess turned him into a narcissus.

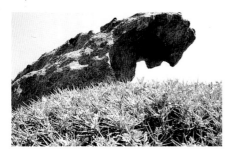

Sleep, 1937
Oil on canvas
51 x 78 cm
Privately owned

Crutches support the head at the nostrils, lips, and ears so that the face seems to float over the ground. The construction provides a precarious balance that allows sleep, otherwise the head would (according to Dalí) "fall into an empty space and be jerked awake, agitating the heart through paralyzing fear."

Cap de Creus, the Sleeping Rock. Geology, 1958

The rock formation at Cap de Creus, which inspired Dalí for *Sleep*, is also called "The Sleeping Rock" by locals. In the picture, the heavy rock has broken away from the ground, embodying Dalí's fear of falling. Not until the 1940s, when pictorial motifs float in space without crutches, did he overcome this fear.

no longer able to return to Catalonia, which for the time being was dominated by Republican-minded workers. It was not until 1940 that he briefly returned to Port Lligat, to say goodbye to his father before emigrating with Gala to the USA via Lisbon.

Until then, Gala and Dalí lived mainly in Italy, where the painter devoted himself to an intensive study of the Renaissance. This was of great importance for his later artistic development, as during this period he acquired an extensive familiarity with traditional painting techniques and art history.

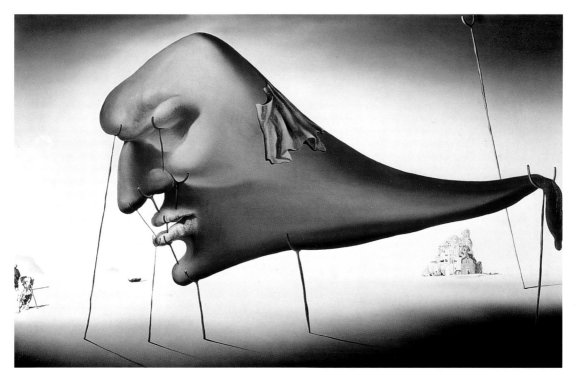

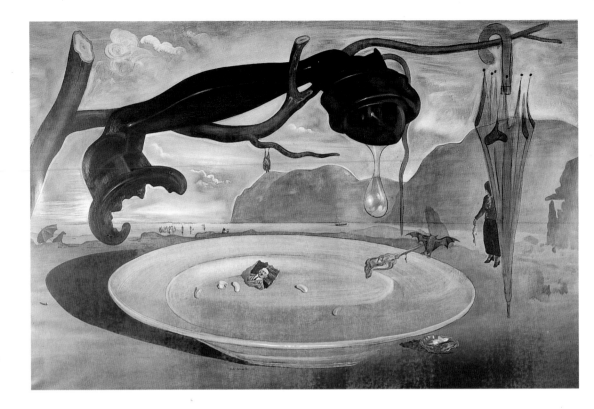

Under the Spell of Politics

Civil war in Spain broke out on July 17, 1936 with a coup by Franco's fascists against the Republican government. Most European and American intellectuals sympathized with the Republicans, and some of them fought on the Republican side. Dalí for his part went to Italy to prepare for his next exhibition in New York. His attitude was mixed: initially he claimed he sympathized with the Republicans, but when it

became clear that Franco would get the upper hand, he changed sides to ensure that he could return to Spain after the war, because he was convinced that only in Port Lligat would he be capable of really important artistic achievements. Independently of his political attitude to the civil war, he painted some pictures representing the horrors of this war; others date from before the outbreak of the conflict.

The looming Second World War also featured in his painting. Hitler's seizure of power had already fascinated him, although Dalí was careful

The Enigma of Hitler, 1938
Oil on canvas
51.2 x 79.3 cm
Museo Nacional Centro de Arte Reina Sofía, Madrid

The desolation of the landscape, the sawn-off tree, and the crumbling telephone receiver with ripped-off wire are a premonition of the failure of peace moves. This work dates from the time of the Munich conference.

Soft Construction with Boiled Beans – Premonition of Civil War, 1936
Oil on canvas
100 x 99 cm
Louise and Walter Arensberg Collection, Museum of Art, Philadelphia

Dalí translates the horrors of the imminent civil war into metaphors that express the desire to kill and mutilate. Two huge but incomplete human bodies kick and tear at each other as if insane and thereby strangle themselves. Some boiled beans are the last remains of a meal to be found in an ossified landscape. In antiquity, beans were sacrificial offerings, used to appease gods and evil spirits, and are also fasting food and symbols of hunger and war. Dalí often stressed that he painted this picture six months before the outbreak of the civil war. Even if it is a response to a specific political situation, the picture is nonetheless conceived as a timeless condemnation.

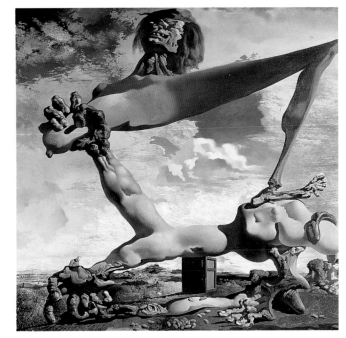

to assert time and again that this fascination was not of a political nature. In many pre-war works, a telephone appears floating over the landscape. It alludes to the negotiations between the British prime minister Neville Chamberlain and Hitler, frequently carried out on the phone, and symbolizes the political mood in pre-war Europe.

The Spanish Civil War altered none of my ideas. On the contrary, it favored the decisive rigor of their development. Revulsion and loathing of every kind of revolution took on almost pathological traits in me.

Salvador Dalí

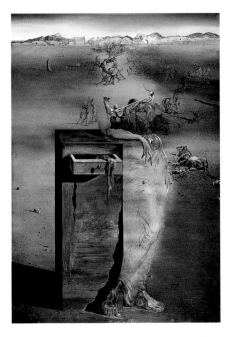

Spain, ca. 1938
Oil on canvas
91.8 x 60.2 cm
Museum Boijmans van Beuningen, Rotterdam

Tormented by civil war, Spain appears in this puzzle picture as a female allegorical figure whose head and bust dissolve into the fighting figures and riders of a battle melée. Here Dalí is quoting from Leonardo da Vinci's drawings of the Battle of Anghiari (1505), when Florence defeated Pisa.

Picture Puzzles

Dalí's "critical paranoia" consisted mainly in detecting new motifs in already existing pictures and objects by means of hallucination and rendering them visible in art. Paranoia was, therefore, seen by Dalí not as a morbid condition but was employed as creative potential. It was of course not a wholly novel approach, because other artists had already drawn inspiration from certain irregular forms such as clouds, stains, and rocks, and tried to discover one or even several completely different figures in them. This altered perception of reality determines the optical ambiguity of the puzzle pictures.

One of the best-known is

Dalí's painting *Endless Enigma* of 1938. The landscape of Cap de Creus depicted in this picture looks strange even at first glance, but the six different readings of the painting can only be made out on closer examination. Dalí succeeds in getting different ways of interpreting the subject matter, but not by defamiliarization: whether the viewer recognizes a landscape, a reclining person or a greyhound depends much more on whether he is capable of combining certain lines and shadows or individual pictorial features with each other in a new way, and can focus his gaze on a particular area and ignore others. Dalí recorded in drawings the different ways

of reading the subject matter: 1. Cap de Creus shoreline with a seated woman seen from behind patching a sail, and a boat; 2. a reclining philosopher; 3. the face of a large, stupid Cyclops; 4. a greyhound; 5. a mandolin, fruit bowl with pears and two figs on a table; 6. a mythological beast. The puzzle picture calls on the imagination of the viewer, and makes it impossible to immerse oneself contemplatively and entirely in the subject. As no configuration predominates, the viewer is offered a restless alternation between the various interpretations.

Dalí's "critical paranoia" does not attempt to offer a balanced description of reality but aims to enrich the

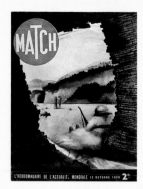

Appearance of a War Scene in the Face of Lieutenant Deschanel (cover page of *Match* magazine), 1939
Pencil and Indian ink on the cover page of a magazine
35.6 x 27.1 cm
Privately owned

subject matter with associations via the medium of delusion. Unlike the Surrealist method of automatism, however, which demands free, spontaneous, associations, in Dalí's puzzle pictures existing perceptions, hallucinations and pictures can be interpreted with the use of critical paranoia.

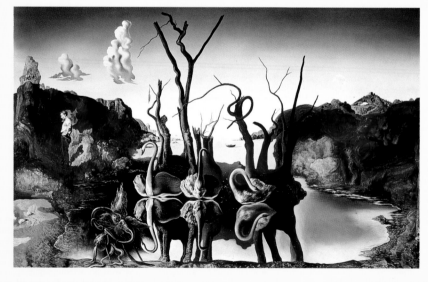

Swans Reflect Elephants, 1937
Oil on canvas
51 x 77 cm
Cavalieri Holding Co. Inca., Geneva

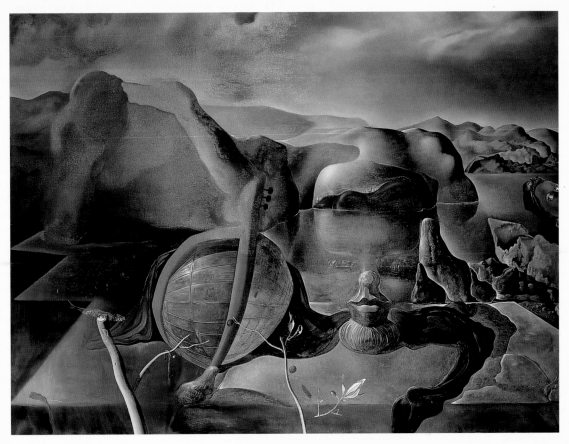

Drawings by Salvador Dalí for his exhibition catalog at Julien Levy's gallery in New York, 1939

Top:
Face of the large, stupid Cyclops; mythological beast

Left:
Mandolin, fruit bowl with pears and two figs on a table; reclining philosopher

Endless Enigma, 1938
Oil on canvas
114.3 x 144 cm
Museo Nacional Centro de Arte Reina Sofía, Madrid

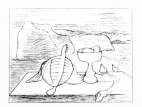

International successes

In May 1936, an International Surrealist Exhibition took place in London at which some of Dalí's works were shown. In the same year, the artist was also represented in the Fantastic Art, Dada, and Surrealism show at the Museum of Modern Art in New York, which earned him further popularity in the USA. How important Dalí's participation in this legendary exhibition was considered is indicated by the portrait of him by Man Ray on the cover of *Time* magazine, which informed its readers that without the painter Surrealism would never have scored such a success in the USA.

A reception of this sort in the USA was of course overwhelming, especially because Gala and Dalí had ensured that the last day of their previous stay in New York in 1934 had ended in uproar. On that occasion, Gala had appeared at a fancy dress ball she was invited to with a baby

Top:
Gala and Dalí in New York, 1934

Left:
Face of Mae West (can be used as Surrealist apartment), 1934–1935
Gouache on newspaper
31 x 17 cm
Art Institute, Chicago

Right:
Venus de Milo with Drawer, 1936
Bronze with plaster-like mount and fur tassels
98 x 32.5 x 34 cm
Museum Boijmans van Beuningen, Rotterdam

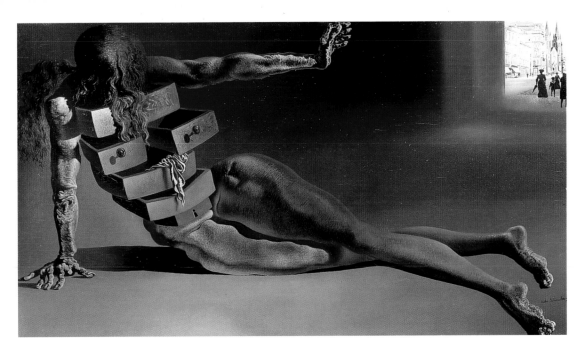

doll on her head. The doll had a gaping wound on its forehead crawling with ants. The press had taken the doll to represent the corpse of a baby, interpreting it as an allusion to the Lindbergh baby abducted and murdered shortly before. General indignation was the result, as the American public strongly sympathized with the grieving father, national hero Charles Lindbergh, who had first crossed the Atlantic in a solo flight in 1927. Although Dalí kept reassuring everyone that no such allusion had been intended, the press pursued them to Europe with the scandal, until Gala and Dalí finally retreated to Port Lligat to get some peace.

In the period after his second New York stay in December 1936, Dalí was able to sign a contract with his friend and patron Edward James, a very wealthy Englishman, that guaranteed him a regular income. This financial safeguard was linked with a creative inducement, in that the painter could now work undisturbed by negotiations with art dealers, gallery owners or collectors. As long as the Civil War in Spain lasted, no return to Port Lligat was possible, so the Dalís were left to live in hotel rooms in Paris and Italy – but at least they could afford it now. Due to countless exhibitions and positive reviews, the painter had reached a peak of international fame.

Anthropomorphic cupboard with drawers, 1936
Oil on wood
25.4 x 44.2 cm
Kunstsammlung Nordrhein-Westfalen, Düsseldorf

Dali used people whose bodies have drawers opening out of them in varying ways as motifs in numerous paintings and also objects. For the painter, the drawers constituted symbols of memory and the subconscious. At the same time, they also refer to "compartmentalized thought," a concept familiar to Dalí from his readings of Freud.

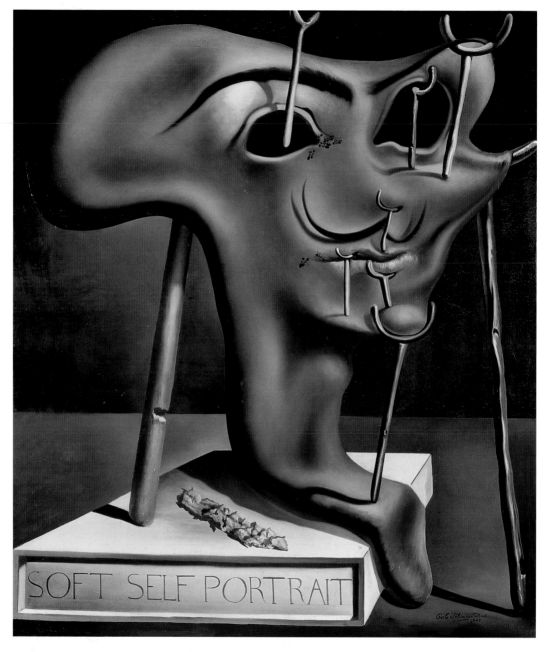

In the eight years of his exile, Dalí painted relatively little, compared with the highly productive period following his meeting with Gala. He wrote his first autobiography *The Secret Life of Salvador Dalí* and devoted himself to commissioned work. He turned out numerous book illustrations, stage sets, fashion designs, and store window decorations. He designed jewelry, and worked in advertising and for various large periodicals. During his exile, hints of nostalgia for his Catholic roots and a turn towards Classicism became apparent. He noted in his autobiography: "Up to this moment I have not found a creed yet, and I believe I shall die without heaven," and illustrated the sentence with a drawing that showed a figure outside a Renaissance church. It raises its left hand, which carries a cross, to the sky as if waiting for inspiration or a sign from God.

Einstein goes into exile in the USA, 1940

Dalí in Venice, 1948

1940 Prokofiev composes *Romeo and Juliet*.

1942 Max Ernst paints *Surrealism and Painting*.

1945 First atomic bomb dropped on Hiroshima. End of the Second World War.

1947 Milton Rynold flies round the world in 79 hours.

1948 The United Nations agrees General Declaration of Human Rights.

1940 Dalí and Gala escape to the USA because of the Second World War.

1941 Retrospective of works by Joan Miró and Dalí at the Museum of Modern Art in New York.

1942 Dalí publishes the *Secret Life of Salvador Dalí*.

1944 Publication of the novel *Hidden Faces*. Première of the ballet *Bacchanal*.

1945 Shocked by the dropping of the atomic bomb on Hiroshima and Nagasaki, Dalí becomes absorbed in nuclear physics.

1946 *The Temptation of St. Anthony*.

1948 The Dalís return to Europe.

Opposite:
Soft Self-Portrait with Fried Bacon, 1941
Oil on canvas
61.3 x 50.8 cm
Fundación Gala-Salvador Dalí, Figueras

Right:
Dalí and Gala at the Hotel St. Regis in New York, 1947

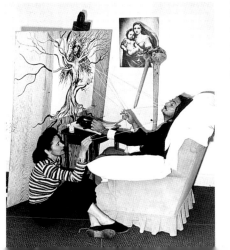

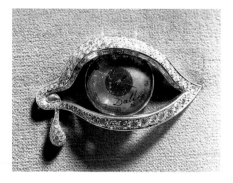

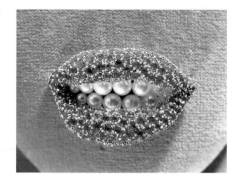

The Eye of Time, 1949
Enamel, diamonds,
and rubies
4 x 6.4 x 1.5 cm
Whereabouts
unknown

Ruby Lips, 1950
Rubies, pearls, and
gold
3 x 5 x 1 cm
Whereabouts
unknown

Avida Dollars

Dalí's commercial works during his American exile prompted André Breton to rewrite Dalí's name as the anagram "Avida Dollars," that is "avid for dollars." Dalí himself was proud of all the money that he was currently earning in the USA.

In collaboration with the Duke of Verdura, a friend of the fashion designer Coco Chanel, the artist designed various pieces of jewelry that playfully pick up some of the key elements of Dalí's stock of shapes and motifs. Among his commissioned works were many portraits of people from high society. Dalí's style of painting, which was capable of capturing a face with almost photo-realistic precision at the same time transposing it into a surrealist dream world, was very fashionable in the US establishment. Among those he painted were Jack Warner, who was co-owner of the film company Warner Brothers, and Helena Rubinstein.

As previously in Paris, the Dalís took full part in social life with great

Night in a Surrealist Forest, charity ball for the benefit of artists in exile, 1941

The decorations used 2,000 pine trees, four thousand jute sacks, and 24 animal heads.

zest, and were themselves counted as prominent personalities. At a ball they organized in 1941 for the benefit of exiled artists at the Del Monte Hotel in Pebble Beach, California, there was such a crush they could scarcely accommodate all the guests. Among the visitors were celebrities such as Alfred Hitchcock, Bing Crosby, Ginger Rogers, and Clark Gable.

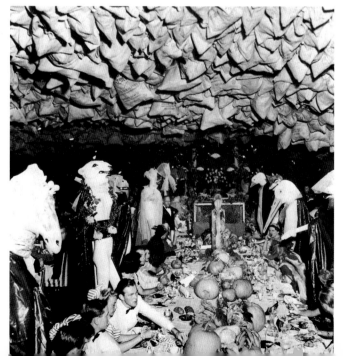

The extravagant and imaginatively decorated celebration was preceded by expensive preparations, which ended in financial disaster. Instead of raising money as planned, the hotelier had to pay out instead. Dalí of course was able to book the occasion to his own account as an effective advertising campaign.

How successful the painter was artistically in America is indicated by a retrospective of works by Miró and Dalí at the Museum of Modern Art in New York in 1941. It attracted countless visitors and got overwhelmingly positive reviews in the press. For Dalí, who was only 37, the exhibition at this famous and at the time leading showcase of contemporary art represented a milestone in his career.

The artist also used his first year in the USA to complete his unfinished autobiography *The Secret Life of Salvador Dalí*. The book was written at the house of his friend and patron Caresse Crosby in Virginia. The writer Henry Miller was there at the same time working on his novel *Tropic of Capricorn*, together with his girlfriend Anaïs Nin, so that things were rather cramped. Appearing finally in 1942, *The Secret Life of Salvador Dalí* was savaged by the critics because the book did not correspond to the notion of a classical autobiography. It was in fact much more the artist putting himself on show in a production where there was no distinction between life and work. The childhood and youth thus described in the book are not reality

but, virtually, a total fabrication – a fact that can of course also be attributed to the psychological problems of Dalí and the disturbed relationship he had with his family.

Interpretation Design for a Stable Library, 1942
Chromos, overpainted with gouache and Indian ink
51 x 45 cm
Fundación Gala-Salvador Dalí, Figueras

As the picture demonstrates, Dalí deliberately included kitsch features in many of his commissioned works.

Dalí and Film

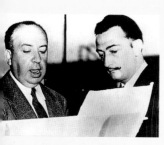

I wanted to avoid every kind of cliché … for me, Dalí was best suited to design the dream sequences … so I went and got Dalí.

Alfred Hitchcock

Above:
Dalí with Gregory Peck and Ingrid Bergman, the stars of the film *Spellbound*, 1945

Top:
Salvador Dalí with Alfred Hitchcock working on the dream scenes for *Spellbound*, 1945

The Eye (design for *Spellbound*), 1945
Oil on wood
Dimensions unknown
Privately owned

Dalí had already had experience with film as a medium in 1929, when he worked with Buñuel on *Un chien andalou*. After the great success of their first joint work, Dalí and Buñuel planned a second film project, the *Age of Gold*. At the preparatory stage, however, it became evident that they had very different ideas for the screenplay, and Dalí quit the project. Even though Buñuel later tried in his memoirs to play down Dalí's role in developing the concept of the film, the correspondence and handwritten alterations on the manuscript prove that Dalí likewise contributed numerous basic ideas and sequences to this film. The première, to which the cream of the Parisian intelligentsia was invited, took place on October 22, 1930 in the absence of both Buñuel and Dalí. In comparison with *Un chien andalou*, the critics were much more reserved. A few weeks later, there was an outbreak of violence at a screening as right-wing extremist thugs forced their way into the film theater, threatened the audience and smashed up the foyer, where an exhibition of

Surrealist books, periodicals, and pictures was on display. News of this incident spread rapidly and was discussed at length in the press. Suddenly, the names of Dalí and Buñuel were on everyone's lips, but in the end the opponents of the film gained the upper hand. In December 1930, the film was banned by the censors, even after they had previously forced some scenes to be cut.

In exile in the USA, Gala and Dalí delighted in the film capital Hollywood. They visited the West Coast of America first in January 1937. Here, Dalí met Harpo Marx, having made a Surrealist object, a harp with strings of barbed wire, for him shortly before. Harpo

returned the favor with a photo showing him playing this harp with bandaged fingers. At their first meeting, they hit it off so well that Dalí wrote a whole scenario for Harpo, although it was never filmed. Dalí's lasting interest in the Marx Brothers is borne out by a screenplay he wrote for them called *The Surrealist Woman*, though again it could not be filmed.

In 1945, Dalí accepted a commission from Alfred Hitchcock for the film *Spellbound*. In this film, psychiatrist Dr. Constance Peterson (Ingrid Bergman) falls in love with a patient (Gregory Peck) who has lost his memory and thinks he has committed a murder. She protects him from the

attentions of the police and finally, with the help of her psycho-analytical skills, is able to bring back his memory.

Dalí's job was to illustrate the patient's dreams in such a way that they contained hints as to his identity and clues to a possible murder. Producer David Selznick thought at first Hitchcock had recruited Dalí for his publicity value, but Hitchock's intention was to get Dalí to design a dream sequence that was bright and sharply contoured, not blurred and ill-defined as had been normal practice in film hitherto. Dalí's sequences were filmed, though partly edited by cutting and overpainting. Dalí was paid a fee of $4,000 for his contribution, an immense sum at the time.

Design for the Disney film
Destino, 1946–1947
Technique and dimensions unknown
Whereabouts unknown

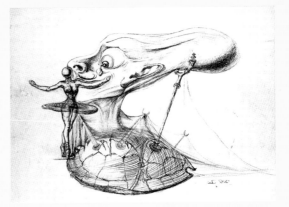

In 1946, Dalí worked on a film project with Disney called *Destino* in which actors and real props would be combined with drawn trick figures and backdrops. A young girl and the god of time Chronos bring monsters into the world, which finally sink into the primeval waters. Dalí declared he had put his entire repertory of Surrealist objects and hallucinations into his designs, and the film could introduce the public to the world of Surrealism better than paintings or the written word.

Three months into the work

Disney dropped the film because the commercial projections were so poor. All that was made was a 15-second sequence in which two tortoises with heads on their backs move towards each other and a ballerina becomes visible between their heads.

Although the project was never realized, Disney described the collaboration with Dalí as very productive, and the two remained friendly for many years.

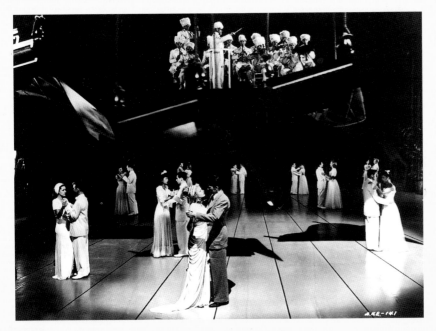

The ball scene in
Spellbound, produced from designs by Dalí. The scene was later cut, 1945

The Surrealists Conquer New York

Quite a number of the Parisian Surrealist group, including André Breton, Max Ernst, Yves Tanguy and Marcel Duchamp, had also emigrated meanwhile and were living in New York. But whereas Dalí had been known and popular in the USA for years, others found it difficult to break into the American art scene. Breton in particular had problems finding his feet in exile, especially as he refused to write his works in any other language than French. Although Dalí did not speak English well and retained a strong Spanish accent, he could make himself understood. In the USA, he was considered a leading representative of European Surrealism, but in the meantime most members of the group rejected him because of his self-publicizing appear-

Dream Caused by the Flight of a Bee around a Pomegranate, a Second before Waking up, 1944
Oil on canvas
51 x 40.5 cm
Fondazione Thyssen-Bornemisza, Lugano-Castagnola

The floating woman and thin elephant legs are the first treatment of the phenomenon of levitation in Dalí's oeuvre.

Max Ernst
The Temptation of St. Anthony, 1945
Oil on canvas
108 x 128 cm
Wilhelm Lehmbruck Museum, Duisburg

ances in public and his commercial work. Breton's view, which many shared, was that "Dalí only hears the squeaking of his patent leather shoes." Dalí's estrangement from his old friends, who for the greater part lived in New York, was reinforced by his frequent absences – Pebble Beach, California, was now his second home. As in Europe, where they had gone back and forth between Paris and Port Lligat, in summer they retreated to the West Coast, where the geological formations reminded Dalí of his native coast.

Dalí's retreat from Surrealist ideals now also became perceptible in his works. Paintings such as *Dream Caused by the Flight of a Bee* or *The Temptation of St. Anthony* indicate a search for a new artistic approach. They were typical of the period of transition from Dalí's Surrealist phase to his period of "nuclear mysticism" inasmuch as

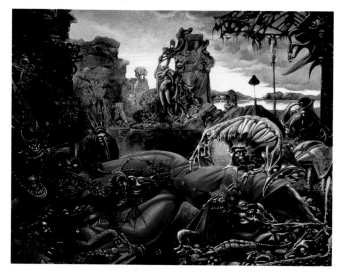

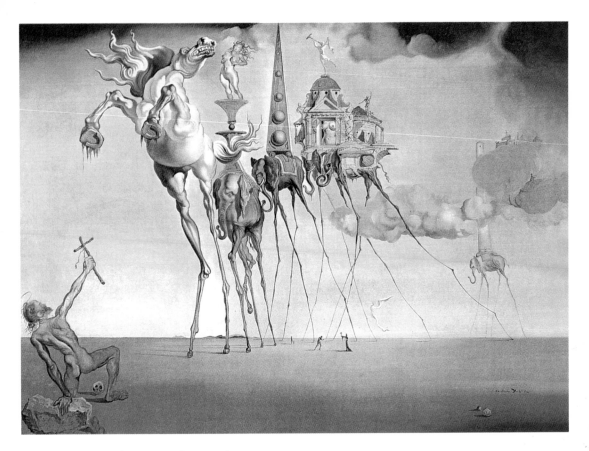

they continue to feature nightmarish visions, but the floating pictorial motifs and suspension of gravity foreshadow an engagement with scientific topics. These would predominate in the pictures Dalí would paint after his return from exile.

The Temptation of St. Anthony, 1946
Oil on canvas
89.7 x 119.5 cm
Musées Royaux des Beaux Arts de Belgique, Brussels

Dalí's version of the *Temptation of St. Anthony* was painted for a competition. The American producer Albert Levin, who wanted to make a film of Guy de Maupassant's novel

Bel-Ami, had invited various Surrealist artists to design a poster. Besides Dalí, the others were Max Ernst, Leonora Carrington, Dorothea Tanning and Paul Delvaux. The jury which would decide the award was made up of Marcel Duchamp, Alfred H. Barr Jr., and Sidney Janis. The prize was ultimately awarded to Max Ernst. The horse rearing at the sign of

the Cross in Dalí's picture is a symbol of power and lust. The elephants carry sexual attributes in the form of a naked woman and the phallic obelisk.

Dalí on the Stage

Dalí had made a first attempt at a project for the stage jointly with Lorca, in 1934. The idea was only realized in 1939 in the form of a ballet called *Bacchanal*, when the Marqués de Cuevas, who was married to a rich Rockefeller heiress and acted as patron to the famed Ballets Russes, declared himself willing to finance the project. The performance would be choreographed by Léonide Massine to music by Wagner. The main character of the piece was Ludwig II, king of Bavaria, who as Tannhäuser slays a dragon with Lohengrin's sword. In his set, Dalí mixed elements from Wagner operas with the classical myth of Leda and the swan. The costumes were designed by couturier Coco Chanel. When the Ballets Russes fled to the USA at the outbreak of war, Coco Chanel had not completed the costumes. Shortly before the première, a New York costume designer finally had to improvise the clothes from photos sent to her from France. Not

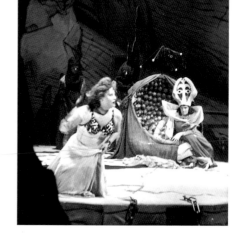

Richard Strauss's opera *Salome* in a performance at the Royal Opera House, Covent Garden, London 1949

The photo shows Salome (Ljuba Welitsch) and Herod (Franz Lechleichner), with costumes and set by Dalí.

Model of a stage set for *Labyrinth*, 1941
Oil on canvas
39 x 64 cm
Privately owned, Spain

The bust of the young man with sunken head represents the entrance to the minotaur's labyrinth. In the background, the silhouette of Arnold Böcklin's painting *Island of the Dead* is visible.

least because of the permissiveness of the costumes, which had some of the dancers appearing virtually naked, the première was a fiasco.

In a second ballet called *Labyrinth*, likewise financed by the Marqués de Cuevas, Dalí was not only to develop the set and costumes but also to write the libretto. Once again he worked with Léonide Massine who was the choreographer. The music for the piece, which was about the myth of the minotaur, came from Schubert's Seventh Symphony. The hero of the action, Theseus, is commissioned to kill the minotaur, a monster half-bull, half-human lurking in the labyrinth. After he has successfully carried out the task, he is able to escape from the labyrinth with the help of a thread laid out by Ariadne. The première of *Labyrinth* in New York in October 1941 was received with enthusiastic reviews.

In October 1944, Dalí did the designs for the ballet *Colloquium of*

Feelings, the subject matter of which was taken from a poem by the French poet Verlaine. The music was written by Paul Bowles, who had not familiarized himself with Dalí's ideas. When Bowles, who later achieved worldwide fame as a writer, attended the dress rehearsal, he was appalled. Although the Marqués de Cuevas had promised him that the ballet would be spared Dalí's usual extravaganzas, the sets showed the artist's whole repertory of nightmarish Surrealist symbols. According to Bowles, the piece was accompanied from beginning to end by whistling from the audience.

For Dalí, the success or failure of the performances was of little importance. In his frequent collaboration with the Marqués de Cuevas he had found an ideal opportunity to unfold his creative potential and at the same time earn money relatively quickly. Whether a piece turned out to be a success or a fiasco mattered little, inasmuch as Dalí's productions garnered a lot of publicity either way.

Ballet scene from *Bacchanal*, danced by Ballets Russes at the Metropolitan Opera House, November 1939

In the *Bacchanal*, the dancers came on stage through the breast of an outsize swan with outstretched wings.

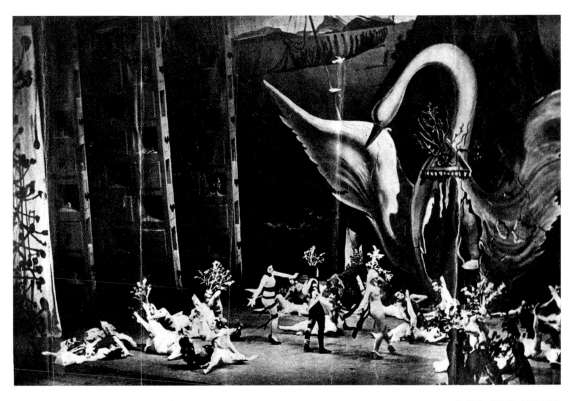

The Poetry of America

The outbreak of war hit the international art market, and Dalí's works found noticeably fewer buyers. Many friends and collectors from Europe now had their own problems getting at their fortunes. Without commissions and portraits, the Dalís would have been in dire financial straits time and again. In 1943 their uncertain situation changed when they met Reynold and Eleanor Morse. The American businessman and his wife already possessed some Surrealist works of art, and had got to know Dalí's work through a friend. Their enthusiasm for the artist's work found expression in building a comprehensive collection of his works,

The Poetry of America – the Cosmic Athletes, 1943
Oil on canvas
116.8 x 78.7 cm
Fundación Gala-Salvador Dalí, Figueras

The consumer product (a Coca Cola bottle, hanging between the two figures) that Dalí includes in his painting has developed into a symbol of the economic power of the USA. The myths of the American consumer society would become a central theme of pop art in the 1960s.

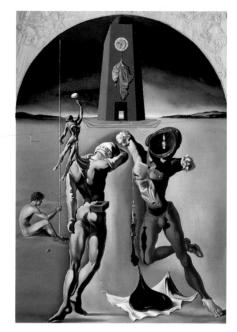

Allegory of American Christmas, 1943
Oil and gouache on card
40.5 x 30.5 cm
Privately owned

This picture featured as an illustration in the Christmas issue of *Esquire* magazine. Over a snowy landscape, an airplane breaks its way out of a giant egg symbolizing Christmas, like an insect out of a cocoon. The hole through which the plane escapes is shaped like North America.

which is today the basis of the Salvador Dalí Museum's collection in St. Petersburg, Florida. Regular purchases by the Morses allowed Dalí to devote himself to his artistic work untroubled by financial worries.

Even the pictures which he did during his exile in America contain the wide landscapes of his Catalan homeland and the cliffs of Cadaqués. However, in some pictures elements now appear reflecting the myths and problems of American society. The *Poetry of America* has been interpreted as a condemnation of the racism of whites towards the black population. In this interpretation, the rival of the white football player gives birth to a new man, who balances an egg as symbol of a new order. In Christian symbolism, the

egg stands for the Resurrection of Jesus, also for purity and perfection. According to Dalí, this painting belongs among the pictures warning of great wars. In terms of content, therefore, it ranks among the works from the time of the Spanish Civil War, which likewise contain allusions to political problems and violent conflicts (see pages 40–41).

Melancholy Atomic and Uranium Idyll, 1945
Oil on canvas
65 x 85 cm
Museo Nacional Centro de Arte Reina Sofía, Madrid

Dalí was so shocked by the dropping of the atom bomb on Hiroshima that he immediately produced a picture on this topic, though still redeploying his stock of motifs from the Surrealist period of the 1930s, notably the head in the foreground, the soft watch being eaten by ants, and the figure of the small boy. At the same time, the picture also includes elements typical of the American period, including the football and baseball players or the pocket watch, the shape of which is reminiscent of South America.

The painting shows Dalí's growing interest in science, and marks the beginning of his intensive preoccupation with the latest discoveries of atomic theory.

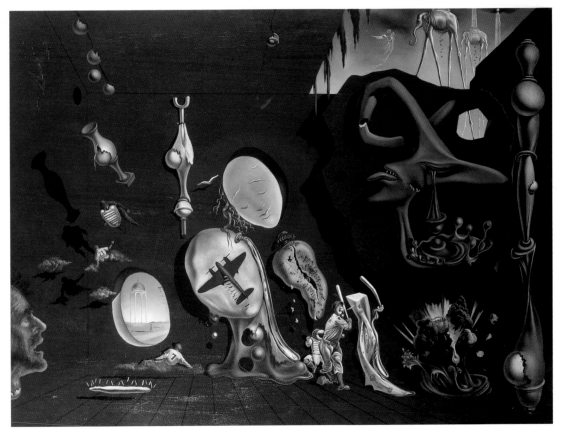

Nuclear Mysticism

1948–1958

In July 1948, Gala and Salvador Dalí returned to Europe. For eight years, they had lived exclusively in the USA. Henceforth, they spent the summer in Port Lligat, the autumn in Paris, and the winter in New York. In Dalí's work two thematic focuses stand out during this period. On the one hand, the artist dealt intensively with scientific phenomena and atomic theory, and in this context came up with the concept of "atomic" or "nuclear" painting. On the other hand, he produced pictures such as the *Madonna of Port Lligat*, dealing with classical and religious subjects. After signs of a return to Catholicism had made themselves evident in the 1940s, the painter now explored his religious roots more extensively and studied the Spanish mystics. In 1949, the pope granted him a private audience, at which he showed the pope the *Madonna of Port Lligat*.

Jeanne Moreau and Miles Davis, 1957

1953 DNA code is cracked.

1954 Death of Henri Matisse. The first Russian atomic power station becomes operational.

1957 Civil Rights Bill promulgated in the USA.

1958 Charles H. Towens and Arthur Schalow invent the laser.

Dalí in New York, 1950s

1949 *Madonna of Port Lligat.* Beginning of religious painting, which is linked with mystic and scientific elements.

1954 The painting *The Christ of St. John of the Cross* appears at the same time as he publishes *Mystic Manifesto*.

1955 Illustrations to Cervantes' *Don Quixote*.

1958 Gala and Dalí marry in church. During an audience, Dalí shows the Pope his picture, *Madonna of Port Lligat*.

Opposite:
Spherical Galatea, 1952 (detail)
Oil on canvas
65 x 54 cm
Fundación Gala-Salvador Dalí, Figueras

Right:
The Royal Heart, 1953
Gold, rubies, diamonds, pearls, and emeralds
Height 10 cm
Minami Art Museum, Tokyo

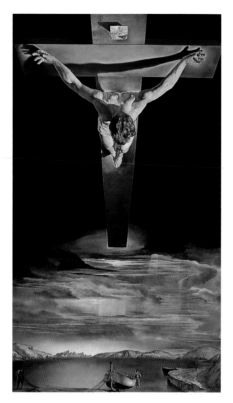

Catholicism

After Dalí had been accorded a private audience by Pope Pius XII, during which the latter had blessed the first version of the *Madonna of Port Lligat*, he professed himself Catholic. After his return from the USA, not only the artist's paintings but also his writings show increasing preoccupation with religious topics. In 1951, Dalí published his *Mystic Manifesto*, with which he wanted to attract attention to his picture *Christ of St. John of the Cross*. It is Dalí's first picture of Christ. It borrows from a small drawing, supposedly by

Christ of St. John of the Cross, 1951
Oil on canvas
205 x 116 cm
Glasgow Art Gallery

Whereas the early sixteenth-century painting of the Crucifixion by the painter Grünewald depicts every detail of the agonizing procedure and shows the viewer Jesus suffering from injuries drawn with graphic precision, Dalí endows his crucified Christ with an immaculate, vigorous physique: "I want my next Christ to be the picture which contains more beauty and joy than all those painted so far. I want to paint a Christ who is in every way and completely the opposite of the materialist and anti-mystic Christ of Grünewald."

Mathias
Grünewald
Christ on the Cross
Isenheim Altar, with both wings closed,
1513–1515
Gum tempera on wood
269 x 307 cm
Musée Unterlinden, Colmar

the sixteenth century Spanish mystic St. John of the Cross, showing Christ from the same unusual perspective. Dalí presents the crucifixion diagonally from above, so that the viewer looks down at Christ almost like an angel or God himself. Neither here nor in his later depictions of Christ does Dalí use the usual attributes of crucifixion such as the crown of thorns, nails, and wounds. "In this picture, my aesthetic purpose was quite the contrary of all Christ figures. My main care was that my Christ should be beautiful, like the God He was," he explained in his view of the subject. The tortured and tormented Christ figures of art history are contrasted with Dalí's beautiful Christ, as he imagined his God. He declared: "God is a personality with a human countenance. But mark: God is constant, whereas we are not." Even so, the artist drew back from giving the Son of God a definite face. His Christ figures are always represented in such a way that their faces are not able to be recognized.

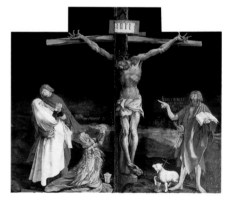

Parallel to these Crucifixions, Dalí painted numerous pictures of angels. The concept of angels interested him particularly, because angels can enter the vault of heaven and communicate with God. In this way union with God, the *unio mystica*, is achieved, which increasingly preoccupied the artist. Perhaps that is why the angelic figures took on Gala's features, who embodied for him purity and sublimity in person.

The originality and importance of the works of this phase of "nuclear mysticism" lie in the combination of religious and mystic motifs with scientific topics. In it, Dalí's image of God becomes visible. In his own words, the artist wanted to believe in a quasi-human God, but his image of God had at the same time to fit the scientific discoveries of the twentieth century. During the period, the Catholic Church was also undergoing a change of attitude in respect to modern science: in 1951, it officially accepted the big bang theory, which explains the creation of the universe by the explosion of extremely dense matter. Until then, the Church had been of the view that the theory contradicted the Biblical story of the Creation, and so had not accepted it.

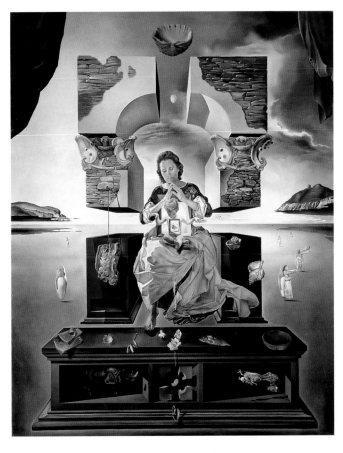

The Madonna of Port Lligat, 1950
Oil on canvas
144 x 96 cm
Minami Group Collection, Tokyo

Dalí's painting was inspired by Piero della Francesca's *Madonna and Saints with Federico da Montefaltro* (1470–1475). Both pictures show an apse in the background and scallop as a symbol of immortality, with an egg hanging to it on a thread. Dalí's apse is falling to bits, as is visible not only in the sundering of the architecture but also the plaster flaking off. This condition could be interpreted as an expression of unbelief, but the weightlessness of the pictorial elements indicates a new form of spirituality. The body of the Madonna has a window-like opening let into it below the hands clasped in prayer, in front of which the Christ child floats. His torso contains a similar aperture in which there is a piece of bread, a symbol of the Eucharist.

Dalí and the Sciences

The explosion of the atomic bomb on August 6, 1945 shook me seismically. Since then, the atom has formed the principal object of my thought.

Salvador Dalí

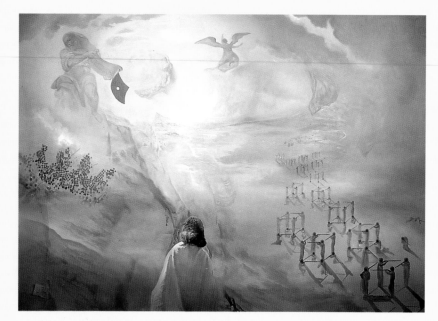

Galacidalacidesoxyribo-nucleicacid, 1963
Oil on canvas
305 x 345 cm
Bank of New England,
Boston

Dalí's pre-occupation with the sciences went back to the 1930s. Even then he had been interested in Einstein's theory of relativity and the question of the relationship of space and time. The first significant appearance in his work resulting from this was the painting *The Persistence of Memory*.

The dropping of the atomic bomb on Hiroshima attracted Dalí's attention to atomic theory. Fascinated by the thought that matter is made up of tiny particles, he began to dissolve the shapes of his pictorial motifs. In this way, he wanted to render the forces between these parts visible and bring his work into line with the latest science view of the world. As he said: "I dissolved matter visually, then spiritualized it, to be able to create energy." His aim was accordingly to allow a spiritual and religious aspect to permeate his scientific approach.

In his painting *Leda Atomica*, Dalí links a scientific topic with a motif drawn from Greek mythology. Even the volutes have detached themselves from the ground. Here Dalí is alluding to the equilibrium of energy between attractive and repelling forces inside the atom. This force relationship corresponds in its turn to the relationship between Leda and the swan in the picture. Unlike the mythical version, where Zeus's attempt to get at Leda as a swan is successful, in Dalí there is no union. Although Leda, who bears Gala's features, faces the swan and compositionally the two form a unit, there is no contact between them. This representation of love as an indissoluble but non-sexual connection matches Dalí's relationship with his wife Gala, as depicted by biographers.

In the 1960s, the painter's interest shifted towards the question of the origin and creation of the universe. In the painting *Galacidalacidesoxyribo-nucleicacid*, a cosmic vision unfolds in front of Gala's eyes. God the Father, whose outline develops from the shapes of the landscape as in Dalí's early puzzle pictures, takes the body of Christ to heaven with him. Besides his arm a DNA molecule can be made out, whose structure had been worked out shortly before the picture was painted. DNA, which stores the genetic information of every living creature, here symbolizes the continuance of life. The crystalline structure opposite illustrates its own destruction, as each of the figures it is made up of could both shoot at another or be shot at by another. Interest in scientific questions runs through

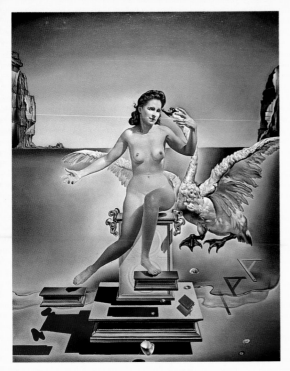

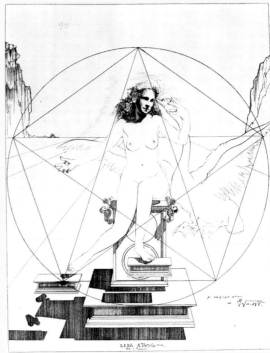

Dalí's whole work. As an enthusiastic reader of scientific periodicals, the artist always kept in touch with the latest discoveries in this area. Even as a 70-year-old, he endeavored to assimilate the then new catastrophe theory. A noticeable feature of all his works on the subject of science is the total absence of any offensive pictorial features. The reason for this may lie in the close connection that existed between science and religion in Dalí's mind.

Leda atomica, 1949
Oil on canvas
61.1 x 45.3 cm
Fundación Gala-Salvador
Dalí, Figueras

Study for *Leda atomica*,
1947
Pen and Indian ink
60.4 x 45.3 cm
Privately owned

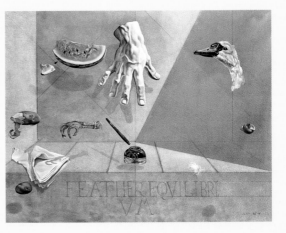

Intra-Atomic Equilibrium of a Swan's Feather, 1947
Oil on canvas
77.5 x 96.5 cm
Fundación Gala-Salvador
Dalí, Figueras

Lectures and Writings

Throughout his life, Dalí wielded the pen almost as often as he wielded his brush; he published two diaries and several pseudo-autobiographical works as well as a novel, some poems and numerous manifestos and essays on art. From the first, his writing activity was as important to him as his painting. As painting and writing were closely related artistic activities in Dalí's view, the artist's notes are an important source for interpreting his paintings.

Title page of the *Mystic Manifesto*, published by Robert J. Godet, Paris 1951

Dalí at his lecture *Les petits lits blancs* **at the exhibition halls in Paris**, ca. 1956/58

An example of the direct connection between writings and paintings is Dalí's *Mystic Manifesto* published in 1951. In this publication, which aimed to get extra publicity for his painting *The Christ of St. John of the Cross* (see page 60), he set out the concept of the picture, which ran contrary to traditional Crucifixion representations. It proved a successful strategy: the picture was sold to the Glasgow Art Gallery for a high price.

Besides his writing activities, in the 1950s Dalí presented himself as a public speaker. Even in his Surrealist phase Dalí had succeeded in both shocking and fascinating the public with his provocative behavior. He now developed his skills in holding an audience with his dandyish extravagances and surprising tricks of rhetoric into a professional career. His lectures, which were notable more for the entertainment value of the person of the speaker than for their content, took him to Madrid in 1951 and various towns in the USA in 1952, where they attracted large audiences.

One of his best known performances was at the Sorbonne in Paris in 1955. Even his arrival was turned into a spectacular event as he drove up in a white Rolls Royce filled to the top with cauliflower. In his speech, he talked about "phenomenological aspects of critical paranoia" and explained to his audience his idea of a connection between Vermeer's famous painting *The Lacemaker*, rhinoceros horns, and logarithmic spirals. The disjointed and scarcely comprehensible train of

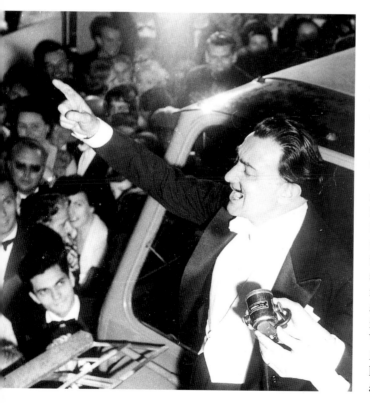

associations served up by the artist, accompanied and inspired by slides, aroused the audience's enthusiasm, and lent the talk the character of an independent work of art.

Critical Paranoiac Painting of Vermeer's *Lacemaker*, 1955
Oil on canvas on wood
27.1 x 22.1 cm
Solomon R Guggenheim Museum, New York

A reproduction of Vermeer's *Lacemaker* hung on the walls of Dalí's parents' house. One day, the picture triggered off a train of associations typical of critical paranoia: some breadcrumbs had bored into the elbow young Salvador had propped on the table, causing him pain. At the same moment, his gaze fell on the *Lacemaker*, which conjured up a vision of rhinoceros. Obsessed with this childhood memory, in 1955 Dalí asked to be allowed to paint a copy of Vermeer's painting. To the surprise of those present, rhinoceros horns appeared on the canvas. Dalí was (or pretended to be) as amazed as everyone else. In his lecture on the subject, he asserted that all he had painted was the logarithmic spirals underlying Vermeer's composition. According to his explanation, these corresponded exactly to the spirals found in the shape of rhinoceros horns.

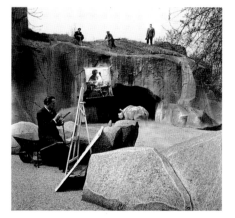

Dalí in the rhinoceros enclosure at Vincennes Zoo with a reproduction of Vermeer's *Lacemaker*, 1955

Dalí is painting rhinoceros horns, while in the background a rhino is being induced to attack a copy of the *Lacemaker*. A cameraman recorded this scene for a film called *Adventure of the Lacemaker and the Rhinoceros*, which was never completed.

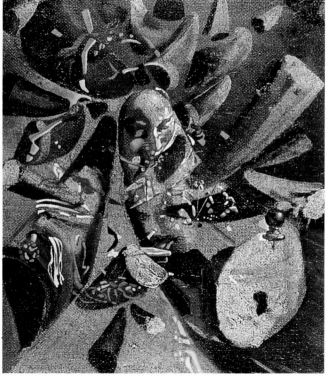

Dalí and Photography

Dalí likes me taking his picture because he is interested in photos that do not simply reproduce reality. Even in photos he prefers to appear outside reality, that is surrealistically ...

Philippe Halsman

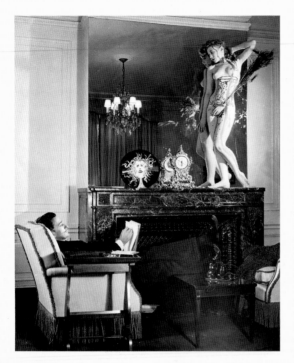

Even in his younger days, Dalí became involved with photography, driven by his inventiveness and aesthetic discoveries. Photography served him as memory, stimulus and of course a measuring rule of his constant self-portrayal. The photographs often create the impression that they were staged by Dalí himself, with the photographer dispatched to the wings as a minor contributor. Only the most famous and best photographers were able to stamp their own indelible imprint on the photos such that the viewer could also see it. The photographs thus chiefly served the myth of Dalí, which he cleverly and with self-willed determination constructed around himself and which he once described as his "greatest work of art." The photographer Marc Lacroix, who was a friend of Dalí's,

reported that in the 1970s the artist began to "put on the Dalí" in front of the waiting cameras, as was expected of him. At the time, Dalí had long been recognized as an artist, but the interest of the public and therefore also the media was directed mainly at the eccentric personality into which he had stylized himself.

In 1937, a portrait photo of him by Man Ray appeared on the cover of *Time* magazine. The occasion was an exhibition of Dada, Surrealism and their precursors in art history at the Museum of Modern Art. Dalí had been selected for the cover of *Time* because "without a good-looking Catalan with a soft voice and twirling actor's mustache Surrealism, would never have reached its present degree of fame in the US," wrote a journalist. Around this time, Dalí began to cultivate the "glassy" look that appears in many of his photographic portraits. He was conscious that he was very photogenic and wanted to increase his popularity with such pictures. Photographers therefore found very patient and ultra flexible sitters in Gala and Salvador Dalí. Interesting portraits were

taken by German-born photographer Eric Schaal, who had fled to the USA in 1936 to escape the Nazis and whom Dalí had met in New York. He presented the artist in a staged Surrealist ambiance between motifs from his paintings, thus making Dalí's dream world appear "real".

A session with British photographer Cecil Beaton yielded some very poetic photos showing Dalí together with Gala between his works. In this series, Beaton plays with the varying auras of the couple.

Left:
Dalí in New York, 1939
Photo by Eric Schaal

Below:
Dalí with the photographer Eric Schaal at a portrait session in New York, 1939

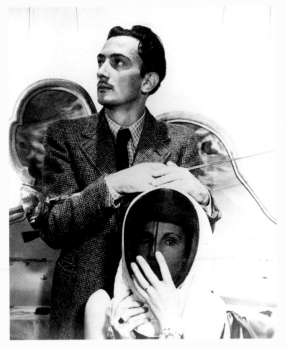

Dalí, with Gala in fencing mask, 1937
Photo by Cecil Beaton

Dalí had himself photographed at work on the project.
In the 1970s, Dalí used stereoscopic photos by Marc Lacroix for visual experiments in which he endeavored to develop three-dimensional painting. Photographic studies were an essential precondition for the highly precise painting technique needed to achieve a spatial painting effect by means of a complicated system of lenses and prisms. Photography ranked high in Dalí's life and work, both as a medium of documentation and an instrument of self-representation. In his own handling of the medium the artist confirmed his creative potential and his delight in experimenting; instead of employing photography only to record reality, he used to stage and "document" surreal events.

Gala is for example furnished with the attributes of a fencer, whereas Dalí stands behind her and looks to one side almost entranced. The eyes of his wife are still visible through the fencing mask she holds in front of her face, fixed on the viewer.
In 1944, Dalí met the photographer Philippe Halsman in Hollywood and soon after began to collaborate with him. The most notable result of this collaboration is the portrait *Dalí Atomicus*, in which all the pictorial components, including the painter, are shown flying through the air. Today, a picture like this can be produced very easily by means of digital processing, but in the 1940s it took hours with the sitter in the studio. The motifs – chairs, cats, and water – were thrown up again and again until Halsman and Dalí were satisfied with the photo they had taken.
In the 1960s and 1970s, the photos often fulfilled the purpose of recording the often spectacular events and actions staged by the artist. Dalí's lithographs of *Don Quixote* for example were produced by the artist shooting paint at the lithographic plate. In order to make his sensational procedure comprehensible,

Dalí at the Atelier Murlot firing paint at a lithographic plate from a gun, 1956

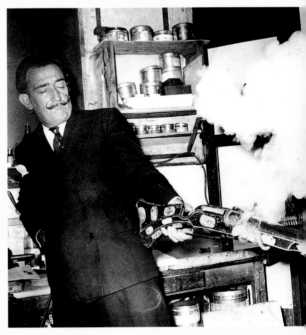

Classicist Tendencies

In 1948, Dalí published a book with the title *50 Magic Secrets*, in which he talked in detail about the business of painting. In this publication, the artist divulged many of his painting techniques, described in detail the qualities of his brush, listed the colors that he used and drew up general rules for the life of a painter. The book totted up the balance of his extensive preoccupation with old masters, which had begun with his stay in Italy in the late 1930s.

Following his return from his sojourn in the United States, when he spent every summer in Spain, Dalí's resumed exploration of the Renaissance resulted in precisely executed graphic studies as preparation for the ambitious compositions of his paintings. For work of this sort, which required intense concentration, Port Lligat offered an ideal environment. The small fisherman's cottage, which the couple had acquired in the 1930s, had meanwhile become a stately complex of interlinked buildings in which Dalí found the quiet and seclusion he needed to paint.

Dalí was particularly taken with the paintings of Raphael and Piero della Francesca, also Spanish painters Velázquez and Zurbarán, whose subject matter and motifs he re-used in very different ways in his own pictures. By using "critical paranoia," his borrowings resulted in completely new and surprising versions of old masterpieces. In some cases,

Jean Auguste Dominique Ingres
La Baigneuse de Valpinçon, 1808
Oil on canvas
146 x 98 cm
Musée du Louvre, Paris

The back view of the nude is one of the classicist painter's masterpieces. Ingres's declared aim was to depict beauty and grace, and his work is noted for its clear and elegant line. His precise manner exudes a certain coolness that contrasts with the erotic flavor of the subject matter. A comparison with the similar view of Gala confirms both Dalí's delight in quoting and his mastery of classical painting techniques.

Gala Naked, seen from Behind, 1960
Oil on canvas
42 x 32 cm
Fundación Gala-Salvador Dalí, Figueras

Dalí depicts his wife, who was over 60 at the time of the painting, as decidedly youthful, thus conferring a timelessness on her presence. In this back view – a pose preferred by Dalí – it seems as if he was looking at the world through her eyes, or as if she had been superimposed on his gaze.

he linked his predilection for the Renaissance with his scientific interests with the result, for example, that a Raphaelesque head would dissolve into particles. Conversely, it was also possible that, using his techniques of free association, the artist could rediscover the work of an old master in any given photograph, as the *Sistine Madonna* demonstrates.

The Sistine Madonna or Madonna Ear, 1958
Oil on canvas
223 x 190 cm
Museum of Modern Art, New York

Dalí wrote a *Anti-Matter Manifesto* for this painting, to explain what it is about. The basis was a photograph of Pope John XXIII he found in a copy of *Paris Match* magazine.

Raphael
Sistine Madonna,
ca. 1513
Oil on canvas
265 x 196 cm
Gemäldegalerie Alte Meister, Dresden

Raphael's famous composition is initially very difficult to find in Dalí's composition of the same name, as the painting is arranged in three planes. At the level nearest to the viewer two papers dangling on threads are shown. Behind them is a gray

halftone, which from a distance can be seen to be an ear. From a still greater distance, the *Sistine Madonna* can be seen in the upper part of the ear. As with the earlier puzzle pictures, the three different readings of Dalí's painting depend not just on the viewer's imagination but also on where he is standing.

As he grew older, Dalí recognized the limitations of painting in his work and endeavored to overcome them with new techniques and by exploring optical perception. His preoccupation with modern science was now transmuted into symbolism, which often overloaded his pictures. Every summer in Port Lligat he painted a monumental picture, which frequently attempted to depict his idea of a link between science and metaphysics via historical subject matter. Stylistically, his borrowings from his own work were blended with classical tradition and echoes of contemporary styles of art. He saw his painting as a means to illustrate his philosophy in a comprehensive structure of life and experience.

Yuri Gagarin, 1961

Dalí and jasmine, October 1959

1961 Yuri Gagarin is the first man in space. Construction of the Berlin Wall.

1963 President John F. Kennedy assassinated.

1964 Beginning of student riots in the USA.

1968 Prague Spring. Soviet troops invade Czechoslovakia.

1969 Woodstock Festival.

1958 Dalí begins a series of monumental history paintings.

1959 Dalí completes *The Discovery of America by Christopher Columbus*.

1963 Dalí begins to take an interest in molecular genetics. He publishes *The Tragic Myth of Millet's Angelus*, the manuscript of which had gone missing for 30 years.

1965 *Perpignan Station*.

1966 *Tunny Fishing*.

1970 Dalí first reveals his plans to build a Dalí museum in Figueras. First European retrospective in Europe at the Boijmans van Beuningen Museum in Rotterdam.

Opposite:
Macrophotographic Self-Portrait with the Appearance of Gala as a Spanish Nun, 1962 (detail)
Gouache on color photograph
78 x 48 cm
Privately owned

Right:
Dalí illustrates his theory of hard and soft, 1958

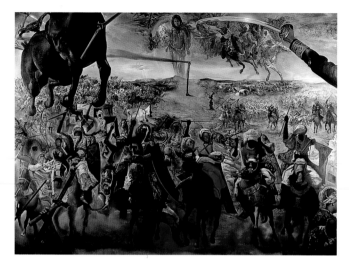

The Battle of Tetuán,
1962
Oil on canvas
308 x 406 cm
Minami Art Museum,
Tokyo

The picture depicts the conquest of the North African town of Tetuán by the Spanish in February 1860. Dalí's painting, which shows him and his wife at the head of the Moroccan troops, seems in fact to focus on illustrating Gala and Dalí conquering the world rather than the historical events. Dalí reverses historical fact, because the painting gives the impression that the heathen, who in fact lost the battle, are generally gaining the upper hand with Dalí and Gala at their head.

History Paintings

In 1958, Dalí began work on his first great picture of a historical (in this case Spanish) legend, and in subsequent years one of these monumental paintings followed every year. The pictures are notable for their dramatic perspectives and grandiose panoramas as much as for their battle scenes and architectural structures. Stylistically, the large-scale paintings are geared towards the pomp and circumstance-oriented, often sensuously erotic history and salon paintings of the late nineteenth century. In the early 1960s these were held in contempt: at a time when abstract styles predominated; their meticulous realism, where the smallest detail could still be clearly made out, was considered inferior and their aesthetic approach an aberration. In championing the history style, Dalí was among the first to help bring about the reassessment of it in the 1980s.

Time and again in Dalí's new style, besides the scenes in which the main topic is treated, individual pictorial features quite irrelevant to the actual subject appear, which are familiar from other works and aspects of Dalí's work. This quasi-

Tunny Fishing,
ca. 1966–1967
Oil on canvas
304 x 404 cm
Fondation Paul
Ricard, Île de Bendor

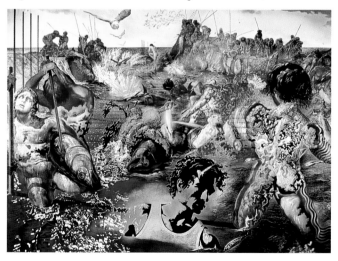

collage approach allowed Dalí to show different time planes of one and the same subject, so that the viewer can read and decode the pictures like a story.

As previously in his Classicist works, Dalí made use of numerous stylistic quotes and incorporated elements from great masters such as Raphael and Leonardo da Vinci. Occasionally the collage approach to composition is tiring for the viewer, when individual scenes of the subject are juxtaposed without connection. If we compare the monumental pictures with the often small-scale works of his Surrealist period, it is noticeable that the history pictures lack the oppressive tension of the early works. Many times they are based on a familiar story, and therefore throw up fewer puzzles than the early works.

Right at the beginning of the 1950s Dalí had attempted to subject his painting technique to certain traditional rules of painting, and thereby refine it still further. He was now interested in classical composition processes, but especially in the Golden Section described in Fra Luca Pacioli's treatise on *Divine Proportion* (1509), which henceforth he used as the dominant compositional principle in his works. These compositional studies contributed substantially to the equilibrium of the very complex structures of the paintings.

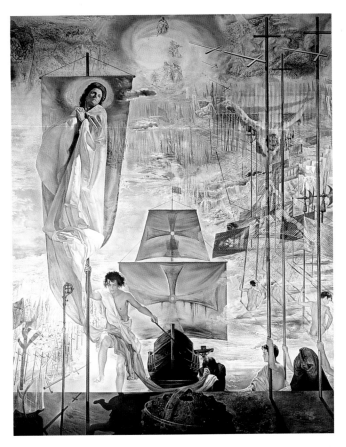

The Discovery of America by Christopher Columbus (Christopher Columbus's Dream), 1958–1959
Oil on canvas
410 x 284 cm
Salvador Dalí Museum, St. Petersburg, Florida

A Madonna with Gala's facial features adorns Columbus's banner, bringing Catholicism to the New World. The lances in the right half of the picture are a quote from Velázquez's famous painting *The Surrender of Breda in 1634*. As a further borrowing, Dalí uses his own *Christ of St. John of the Cross* (see page 60), a ghostly figure between the lances that is repeated in the crucifix of the monk at the bottom edge. Besides the historical subject, the painting also contains biographical features, alluding to the "conquest" of America by Gala and Dalí in the 1940s. Dalí has portrayed himself in the figure of the monk in a cowl at the bottom.

The Dalí Show

Gala had never divorced Paul Eluard. Even after Eluard's premature death in 1952, some years would pass before Gala and Dalí got married in church on August 8, 1958. The amazing thing was that the wedding passed off very quietly, although normally Dalí would have exploited every opportunity for publicity. Around this time a degree of estrangement became apparent between Dalí and Gala, and perhaps the quiet wedding was also intended to assure each other of the inseparability of their relationship. Although Gala continued to look after business matters and negotiated with dealers and collectors, the couple were rarely seen together on official

occasions any more. Gala began to keep younger lovers and spend more and more time with them. Dalí often appeared in the company of Nanita Kalachnikoff, the daughter of Spanish writer José María Carretero, whom the painter called Louis XIV as she reminded him of the French Sun King. She was the focal point of a kind of retinue that Dalí began to gather around him.

From 1965 another woman appeared in Dalí's life, with whom he had had an intensive friendship for ten years, the pop singer Amanda Lear, whose androgynous appearance entranced the painter. She had studied art in London, worked as a model for the great fashion shows, and was friendly with famous rock stars such as Mick Jagger and Marianne

Left:
Dalí in Venice, 1961

The photo shows Dalí in an open veteran car on his way to the première of the ballet *Gala*. The walking stick is wholly typical: Dalí scarcely ventured abroad any more without it. The pistol in the other hand is an allusion to his new method of generating pictures by shooting paint-filled bullets at the canvas or paper. The choreography for this ballet was by Maurice Béjart, while Dalí designed the set and costumes. The stage was filled with disabled people, who

Top and above:
Dalí ca. 1960

threw their crutches in barrels filled with Guerlain scent. In the middle of this scene, the goddess of heaven and earth appeared, and apparently naked dancers prostrated themselves before her. Gala was present at the première and is said to have applauded her representation as a goddess merely with a chilly smile.

Faithfull. Dalí collected such extravagant personalities around him not only for company but because their appearance together would attract additional attention from the public and the press.

To satisfy his hunger for publicity, Dalí increasingly used television, which had developed into a mass medium in the early 1960s. Via television he could reach an audience that was not interested in his art. Like his lectures, several interviews and films turned into spectacles that the artist carefully staged. During an interview with the staid BBC, for example, Dalí interfered so effectively in the production side that, despite the conventional questions, an almost experimental Surrealist film resulted.

Dalí and Picasso had become the best-known living artists of the age. Despite his already great popularity, the painter was constantly searching for different ways to put himself across. In the 1960s and 1970s, therefore, Dalí wooed and won over both film and print media, which were always on the lookout for new, sensational stories.

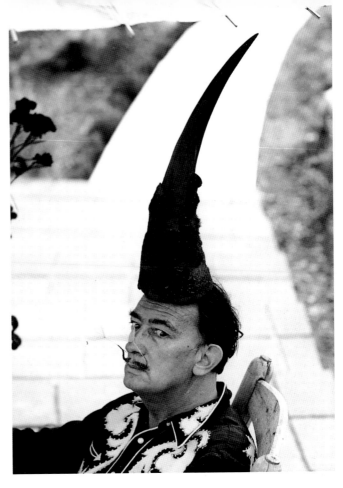

Dalí in Port Lligat, 1959

No prank was beneath Dalí when it came to publicizing his work and ideas in the media. Sometimes the foolery took on a clownish character. In this photo, the painter presents himself with a rhino tusk, such as features in various contexts in his work, balanced on his forehead. Worldwide, the horn is ground to powder to make an aphrodisiac. Dalí viewed it as a phallic shape, which is how it appears in several of his works, for example the *Autosodomized Virgin* (see page 81). He also found it mathematically interesting as an object, because in his view it described a perfect logarithmic curve.

Perpignan Station

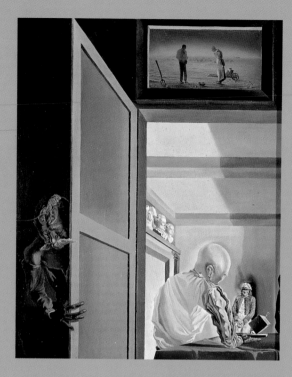

Gala and Millet's *Angelus* shortly before the Immediate Arrival of the Conical Anamorphoses, 1933
Oil on wood
24 x 18.8 cm
National Gallery of Canada, Ottawa

Dalí's painting is dominated by a light source at the center radiating pairs of beams to form a Maltese cross. Dalí himself appears twice in the same attitude, arms and legs outstretched as if in free fall. Indeed, the smaller of the two figures appears to be falling into the light source. Contrasting with this fall, the painter presents the larger figure in suspension.
The man and woman on the left and right hand side, enclosed within the Maltese cross, are directly borrowed from the *Angelus*, both of them suspended over a sack of potatoes. Beside each of the isolated figures, scenes can be made out in silhouette, again the result of Dalí's critical paranoiac approach: the scene on the left shows the woman helping the man to load the wheelbarrow with a sack of potatoes, the scene on the right shows the act of copulation, performed from behind. Between the figures from the *Angelus* in the center is the spectral figure of Christ on the Cross, his

Jean-François Millet
The Angelus (Evening prayers), 1859
Oil on canvas
55.5 x 66 cm
Musée National du Louvre, Paris

Perpignan Station is of especial interest in Dalí's work, inasmuch as it represents a synthesis of his previous work. The artist's work is recycled in a variety of forms, with features from every stylistic phase. They include the cliffs at Port Lligat, critical paranoia, the central motif from Jean-François Millet's painting *The Angelus*, levitation, Christ, religion and mysticism, and science. Dalí's interest in the painting by Millet (1814–1875) dated back to the early 1930s, and was important for his work. The picture had been familiar to him as a reproduction on the wall of his parents' house, and critical paranoia produced this re-interpretation. A couple stand solitary in a field at twilight, facing but not communicating with each other. According to Dalí's interpretation, the man is trying to hide an erection with his hat, while the woman remains in the attitude of a praying mantis as if she wanted to consume her partner post coitus.

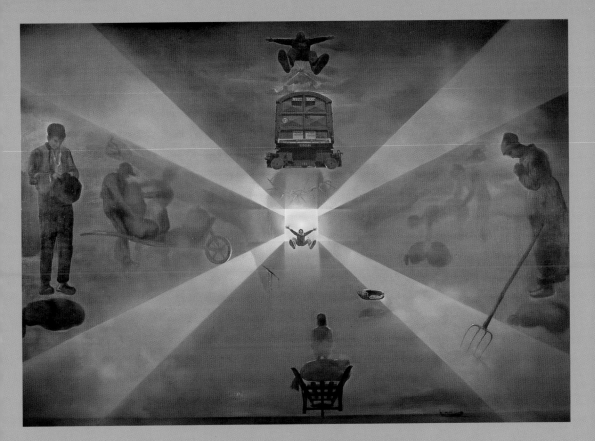

crown of thorns being
apparent beneath the
locomotive. In an X-ray
photo of Millet's picture Dalí
had made out the coffin of a
child at the woman's feet.
The painter had linked this
with Christ's death and his
own person falling into the
light source, all merging into
a single figure.

Perpignan Station, 1965
Oil on canvas
295 x 406 cm
Museum Ludwig, Cologne

Cover of *Diary of a Genius*,
published by Doubleday in
New York, 1965

Don Quixote and Sancho Panza (illustration for Cervantes' *Don Quixote*), 1957
Lithograph
41 x 32.5 cm
Museum of Fine Arts, Boston

Dalí wrote of his illustration:"Don Quixote is a kind of fool, the greatest fetishist in the world, who would like to possess the strangest things the world can offer. For my part, I would like each of my illustrations for *Don Quixote* to be something extremely unusual in respect of the means used for their execution. Each element of these lithographs must contain an element of exaggerated quixoticism." Dalí's vigorous line work made facial features unnecessary, with Quixote being presented as a rotating silhouette. In the left background, the figure of his companion Sancho Panza can be made out as a shadow.

Illustrations

Dalí produced his first illustrations for the literary publications of the Surrealists, but at the same time he provided pictures for writings of his own such as *The Visible Woman* in which the first texts on "critical paranoia" were summed up. The peak of his early involvement with illustration work was reached with illustrations in 1934 for the new edition of *The Songs of Maldoror*, a volume of poetry written by the French writer Lautréamont (1846–1870), whom the Surrealists considered as their precursor because of his style of living and writing.

As the worldwide fame of the artist by then guaranteed high sales, in the 1950s and 1960s numerous publishers showed an interest in collaborating with Dalí. For Dalí too, such commissioned work

The Aura of Cervantes (illustration for Cervantes' *Don Quixote*), 1957
Lithograph
41.7 x 32 cm

represented a welcome and lucrative source of income.

In 1956, the publisher Joseph Fôret commissioned lithographs from him as illustrations for Cervantes' novel *Don Quixote*. Dalí's negative attitude to this printing technique, which he found bureaucratic and "a method without rigor, monarchy, and inquisition," only changed when Fôret allowed him complete freedom as to how he produced the plates. As so often, here too Dalí developed an experimental new technique for the medium. It consisted of firing bullets filled with paint at the plates, and dipping snails in the paint which then left a trail on the plate. Although Dalí claimed all he did after that was sign the plates, further careful work was of course required from the artist, because at this point scenes from the life of Don Quixote

had to be discovered in the painted surfaces which had been thus randomly obtained, and brought out with brush and pen.

From 1962, Dalí collaborated with the publisher Pierre Argilet and illustrated the works of authors as diverse as Guillaume Apollinaire, Arthur Rimbaud, Goethe, Sacher-Masoch, and Mao Tse-tung.

Dalí had been interested in literature since childhood, and often got Gala to read aloud to him while he painted. Pop singer Amanda Lear, who was friendly with Dalí in the 1960s, said that she often took over this duty when Gala was not there. Whether they read the works he was just illustrating is not known, but many illustrations refer recognizably to the text that they were intended to accompany. The illustrations for Dante's *Divine Comedy* for example pick up specific narrative motifs from the cantos and translate them into the artist's typically realistic visual idiom. On the other hand, some experimental abstract lithographs for *Don Quixote* show that the painter might have been inspired by the story but used the free associations of "critical paranoia," so that in such cases it is up to the reader's imagination to find any connection with the text.

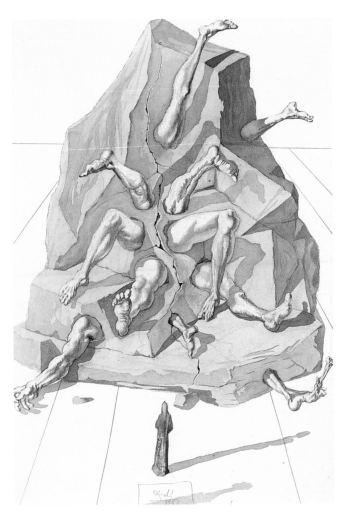

The Followers of Simon (Illustration for Dante's *Divine Comedy*), 1951
Watercolors and sepia on paper
43 x 28 cm
Whereabouts unknown

Dante Alighieri's *Divine Comedy* is a poem of 100 cantos, consisting of an introductory canto followed by 33 cantos each for Heaven, Purgatory, and Paradise. This illustration refers to the story of the heretic Simon Magus and his sinful attempt to acquire a divine gift with money:"From the aperture of each hole projected/ The feet and legs of a sinner/ Up to the calves; the rest remained within," says the relevant text from the 19th Canto of Hell, to which Dalí was specifically referring.

Scandals and Catastrophes

Dalí leaving the police station where he had been taken for questioning after breaking a window at Bonwitt-Teller's store, New York 1939

Dalí dearly loved to provoke. His eccentric behavior had caused sensation even in his student days in Madrid. Initially, his extravagant way of dressing and dandyish manner had merely helped the young man to overcome his shyness in social contacts, but he soon used them deliberately to attract attention. Throughout his life, Dalí aroused comment by his confusing actions and often inexplicable pranks. Dalí was one of the first artists to use publicity as a form of artistic expression, and his spectacular public behavior was a means to make himself and his work better known.

During the great International Surrealist Exhibition in London in 1936, Dalí came on stage for a lecture dressed in a diving suit. As it happened, he could scarcely breathe in it. The public hardly noticed that he was on the point of suffocating, because his cries could not be understood behind the helmet of the diving suit. Only his wild and violent gesticulations eventually drew the audience's attention to his plight, and in the end the caretaker had to release him with a screwdriver.

Young girl standing at the window, 1925
Oil on canvas
103 x 75 cm
Museo Nacional Centro de Arte Reina Sofía, Madrid

In New York, Dalí created a sensation when he did some decorations for the Bonwitt-Teller store, dressing two windows on the theme of Day and Night. When a short while later he came to have another look at his work, he discovered that the decorations had been changed. In protest, he overturned a bath full of water in which a turn of the century mannequin was sitting in the store window. It slipped from his grasp and smashed the window. As he was stepping out of the window through the broken pane, the artist was arrested by a policeman. In the end, Gala and an American well-wisher had to bail him out at the police station. When he came before the court, the judge decided Dalí had reacted unreasonably and should replace the glass, but added that every artist had the right to defend his work to the uttermost. Shortly afterwards, Dalí drew up a

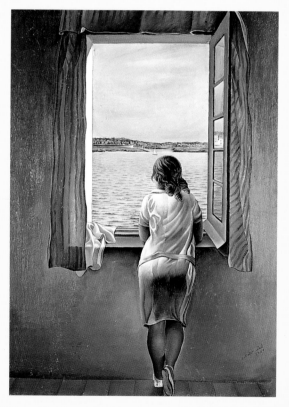

manifesto in his own justification called *Declaration of Independence of the Imagination and Declaration of the Rights of Man to Madness*. As at the outset of the affair, the New York press was delighted and praised him for defending the autonomy of American art.

In 1949, Ana-Maria published her book *Dalí, As Seen By His Sister*. It caused a stir because it refuted the stories and anecdotes about his childhood put about by Dalí himself. Ana-Maria depicted their home life as idyllic and her brother as a normal, lovable boy, describing Salvador's childhood as average. Since their father also vouched for the accuracy of the book in a foreword to the first edition, Dalí was beside himself with rage. For decades he had worked at his image, and now it lay shattered overnight. Once again he crossed swords with his family and painted the *Autosodomized Virgin*, which directly alluded to his sister; as is shown by a comparison with a picture of her from 1925. However, one of the greatest scandals to do with Dalí is of a less amusing nature. In recent years, supposed original drawings by the artist have constantly been

turning up in the art market. According to his own testimony, Dalí always wanted to be so popular that his pictures could be bought in stores, and since the 1960s, anyone with the appropriate financial means could publish Dalí graphics. For Dalí this was another welcome source of income. However, because he was frequently away on his travels, he was often difficult to track down to sign the printed sheets. The artist therefore provided signed blank sheets to overcome this problem. At some point, the idea arose that Dalí's signature alone was worth money. It now seems certain that between 40,000 and

350,000 such signed blank sheets exist, which are used time and again for forgeries.

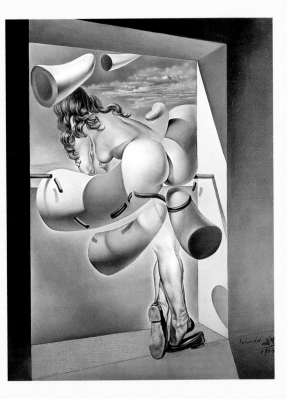

Young Virgin Autosodomized by the Horns of her own Chastity, 1954
Oil on canvas
40.5 x 30.5 cm
Playboy Collection, Los Angeles

Late Experiments 1971–1989

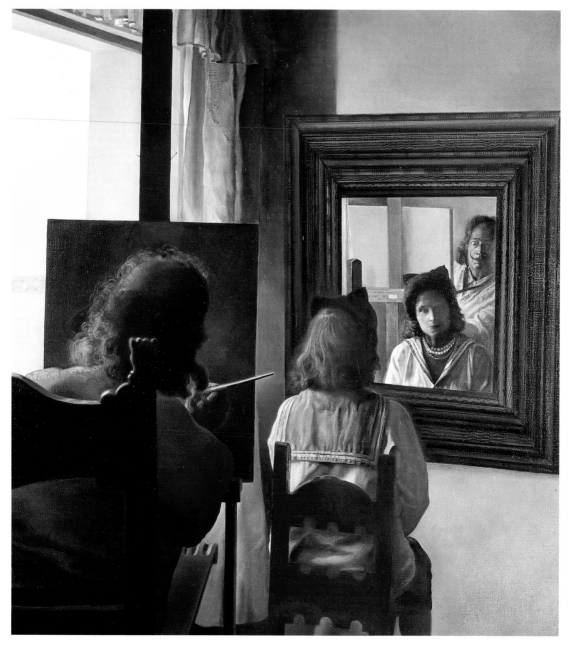

In the 1970s, Dalí painted little and was very busy planning and fitting out his museum in his home town of Figueras. His media presence, and also large retrospectives in important museums, had made him popular worldwide and introduced him to a new, young public. At the same time, he worked on three-dimensional panel pictures based on systems of prisms and mirrors, and artistic holograms, the technology of which has just been discovered.

In 1982 Gala died. Despite the estrangement in the last years before her death, Dalí was deeply shocked and retired increasingly from the public eye. He no longer painted and was obsessed with the idea of being immortal. On January 23, 1989, Dalí died in the Galatea Tower at the museum in Figueras, where he had been living for some time.

Fall of the Berlin Wall, 1989

Dalí in front of a statue of Meissonier, 1971

1972 Watergate Affair leads to resignation of President Nixon in 1974.

1977 Luis Buñuel films the *Obscure Object of Desire*.

1985 Mikhail Gorbachev becomes general secretary of Soviet Communist Party and introduces perestroika into the Soviet Union.

1986 Devastating accident in a reactor at Chernobyl, Ukraine.

1971 Opening of Dalí Museum in Cleveland, Ohio (collection of Eleanor and Reynold Morse). First 3-D experiments.

1974 Opening of Teatro Museo Gala y Salvador Dalí in Figueras.

1978 Gala and Dalí conduct the Spanish royal couple through the museum in Figueras.

1979 Great retrospective at the Centre Georges Pompidou in Paris.

1982 Gala dies.

1983 Dalí paints his last picture, *The Swallowtails*.

1989 Dalí dies on January 23, and is buried in his museum in Figueras.

Opposite:
Dalí from behind painting Gala from behind, who is immortalized by six virtual corneas momentarily reflected in six real mirrors, ca. 1972–1973 (detail, unfinished)
Oil on canvas
Stereoscopic work on two panels, each 60 x 60 cm
Fundación Gala-Salvador Dalí, Figueras

Right:
Bottle of *Dalí-Femme* perfume, 1983

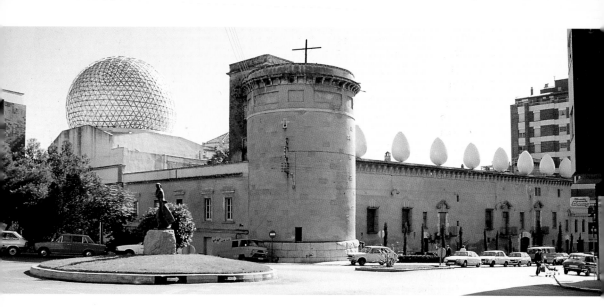

Façade of the Teatro Museo Dalí with the gigantic eggs and the Galatea Tower, which accomodates the administration, library, and photo/video archives.

Figueras

Even in the 1960s, Dalí had turned his mind to the notion of setting up a museum for his works in his native town of Figueras. A suitable building for this was the old municipal theater, where the first exhibition of Dalí works had taken place.

The artist was keen on the idea of being able to open his own museum during his lifetime, and plunged into the designs for the fitting out with tremendous enthusiasm. With meticulous attention he devoted himself to every single detail and, although he was nearly 70, he personally supervised the implementation of the work. Even though the young architect Pérez Piñero, with whom Dalí had collaborated in the plans for converting the building, lost his life in an accident shortly before the construction work was complete,

the museum was opened on time on September 23, 1974, 56 years after his first exhibition had taken place there.

The Teatro Museo Dalí in Figueras can be recognized some way off from the imaginative design of the façade. The large dome vaulting the central space inside and the gigantic eggs along the roof of the building catch the eye. The museum stands on a small hill, and is entered across a small forecourt that Dalí dedicated to the Catalan philosophers Francesco Pujol and Ramón Llul.

Besides numerous oil paintings, which include some of the artist's best works, the Teatro Museo Dalí is home to many stereoscopic pictures and installations from the artist's late work. A particular attraction is a room whose interior, when you look through the door from outside, makes up the face of a woman. The composition goes back to his earlier

collage *Face of Mae West* (see page 44). Also on show are a number of large wall paintings that pick up typical Dalí subjects. Among them in the central hall under the great dome is the stage set for *Bacchanal* (see page 55). With its narrow corridors, which keep opening suddenly into individual large rooms, the inner structure of the museum is totally confusing to the visitor. The labyrinthine impression is reinforced by numerous puzzling objects that Dalí collected during his life and which are now exhibited in the museum as part of his biography. These include many valuable things, such as the canvas of the painter Meissonier of whom Dalí thought highly, but also simple found objects such as pebbles, shells, and bones.

The Teatro Museo Dalí should be viewed as a Surrealist total work of

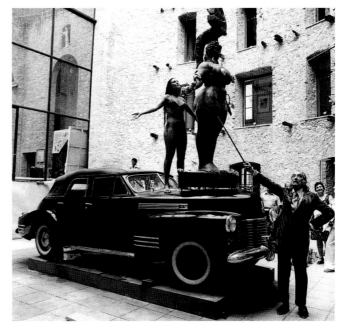

Dalí beside the *Rain Taxi* in the patio of the Teatro Museo Dalí, 1975

The *Rain Taxi* in the museum at Figueras is a recreation of Dalí's Surrealist object of 1938. For this version, Dalí used a Cadillac that was supposed to have belonged to Al Capone. The bulky radiator mascot is a sculpture of *Queen Esther*, which was a gift by the Austrian artist Ernst Fuchs.

art. In the combination of his own creations, the works of other artists that Dalí admired, and the, to some extent quite commonplace, everyday articles, the basis of Dalí's philosophy and oeuvre gradually unfolds to the visitor. As the museum is full of allusions to his life, it could be interpreted as a kind of autobiography. Nowadays, the Teatro Museo Dalí together with the Prado in Madrid and the Guggenheim Museum, is one of the most visited museums in Spain.

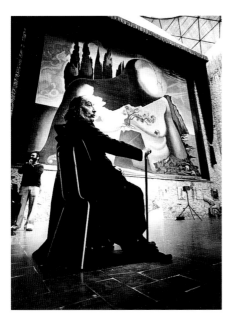

Salvador Dalí in the museum at Figueras, 1977

3-D experiments

In the mid-1970s, Dalí worked on various holograms, as he was intrigued by the possibility of making a real three-dimensional picture. In 1974, he designed a cylindrical hologram entitled *The Shepherd and the Siren*, which exploited the opportunities offered by holography to the full, because the viewer can walk round the hologram and look at it three-dimensionally from all sides. However, he soon abandoned the medium, firstly because he could not produce the hologram himself and had to rely on specialized technicians in the USA, which meant that any problems had to be dealt with by telephone, and secondly, the new technology was still too undeveloped for him to pursue his efforts in this new artistic medium.

At the same time he attempted to achieve three-dimensional results by using a different technology. This second approach was the result of his studies of the Dutch painter Gerard Dou (1613–1675), a pupil of Rembrandt's, whose idiosyncrasy

Holos! Holos! Velázquez! Gabor!,
ca. 1972–1973
Hologram
42 x 57 cm
Fundación Gala-Salvador Dalí,
Figueras

This holographic puzzle picture shows a group of card players, between whom motifs from Velázquez's painting *Las Meninas* appear. On the left is the self-portrait by Velázquez, and above the players' heads the daughter of the Spanish king.

Athens is burning! The School of Athens and the Fire of Borgo, 1979–1980
Stereoscopy, left part
Oil on wood
32.2 x 43.1 cm
Fundación Gala-Salvador Dalí,
Figueras

was painting pictures in multiple copies. Dalí had known Dou's paintings since he was a child, but had never had an opportunity to look at two original works side by side. He therefore had to make do with reproductions when he wanted to examine the different versions of a picture for possible differences. And indeed, Dalí found tiny, at first glance scarcely perceptible differences which led him to suppose that Dou had been conducting stereoscopic experiments.

Stereoscopy is a process that uses two almost identical pictures to generate a three-dimensional effect. The two pictures are brought together in a system of mirrors or prisms so that the viewer gets a spatial impression of the subject, just as human sight delivers. The slightly different perspectives of the left and right eye are merged by superimposition in the brain to produce a three-dimensional perception. A stereoscopic camera

likewise generates two slightly different pictures of the same subject which, when viewed through a special system of lenses, creates a three-dimensional effect.

At the beginning of the 1970s, Dalí painted several stereoscopic works from photographs produced by his photographer friend Marc Lacroix with a special camera. However, the quality of his artistic experiments with three-dimensionality is debatable. In order to achieve the desired spatial effect, the painter had to stick to the photographs very closely and was unable to follow his imagination as normal. The paintings therefore often look like painted copies of photographs, which of course they are, and do not develop any intrinsic qualities. Also, the viewer is tied to a viewing point predetermined by the artist and the technology associated with the work, because the picture the painter intended can only be seen through the lens apparatus installed in front of the picture.

Gala Contemplates the Mediterranean, which at a distance of 20 meters turns into a picture of Abraham Lincoln (homage to Rothko), 1976
Oil on canvas
252.2 x 191.9 cm
Minami Art Museum, Tokyo

Whether viewers see Abraham Lincoln or Gala in this picture depends not only on their distance from the picture. To make Lincoln out, one must try to focus on a single point, ignore the other parts and see the picture as blurred as possible. As an optical puzzle, the painting goes further than the famous puzzle pictures of the 1930s: because of the coloration and chiaroscuro contrasts to the square shapes, after prolonged viewing it becomes uncertain whether the cruciform aperture is really a window opening to the rear or whether it is in fact a projection with *trompe l'œil* painting.

Exhibitions and Art Market

Unlike many others among his artist colleagues, Dalí had been very successful with his exhibitions right from the first as a 14-year-old. On that occasion, some critics from Barcelona had confirmed that the boy had great talent. Similarly, Dalí's first one-man show at the Dalmau Gallery in Barcelona in 1925 received excellent reviews.

Although Dalí was already known in the Paris art world in the 1930s and enjoyed the attention of the public as a Surrealist, commercial success was not immediately forthcoming. Dalí only achieved a level of financial stability in 1936 as a result of an agreement with his friend and patron Edward James, which guaranteed Dalí a regular income. In return, Edward James received all the works that the painter created in the extraordinarily productive period between 1936 and 1939. A great part of this major collection is now in the Tate Gallery in London.

In exile in the USA, Dalí met Eleanor and Reynold Morse, who from the 1940s likewise built up a large collection of works by the painter. Their collection was of such quality and range that the Morses finally set up a special museum for it in Cleveland, Ohio, which opened to the public three years before the museum in Figueras and later moved to St. Petersburg, Florida. Dalí's second American gallery patron George Kellner closed his doors in 1948, following the example of the first, Julien Levy. The highly businesslike Gala then took over the dealing, putting the artist's pictures on the market without the help of a professional intermediary.

The sale of the painting *Christ of St. John of the Cross* (see page 60) to Glasgow Art Gallery in 1951 for £8,200 was greeted by protests from both people at the museum and members of the public. One side found fault with the quality of the picture, the other considered the price completely over the top. However, as the copyright was also sold with the picture, it has produced a steady income for the

Opposite:
Retrospective of the oeuvre of Salvador Dalí at the Centre Georges Pompidou, Paris 1979–1980

museum ever since, through the sale of postcards. The contradictory reception of the picture is typical of Dalí's postwar work. Whereas the art market was willing to pay high sums for Dalí's pictures, the critics found the quality of many pictures mediocre. In December 1979, the Centre Georges Pompidou in Paris opened for a four-month comprehensive retrospective of the works of Dalí from 1920 to 1980. The entrance hall contained a giant Surrealist installation of typical Dalí motifs, while in the exhibition rooms paintings, drawings, graphics, objects, writings, and film works documented the range and variety of his artistic work.

The Staatsgalerie in Stuttgart also planned a large retrospective in collaboration with Zurich's Kunsthaus, to celebrate the painter's 85th birthday, but this became unintentionally the first posthumous presentation following Dalí's death in January 1989. The exhibition organized the artist's oeuvre meticulously, from the earliest to the final works, according to art historical categories, dispensing with over-spectacular effects. This novel approach was successful in shedding new light on and generating new respect for the work, which had often been subordinated to the Dalí publicity machine. Nowadays, some of Dalí's best works fetch prices running into millions. Celebrated pictures like *The Persistence of Memory* (see page 29) are even considered priceless.

Dalí at the Charpentier gallery in front of his Surrealist object *Hommage à Emmanuel Kant*, 1964

Exhibition of sculptures after designs by Dalí in the Place Vendôme in Paris, 1995

Dalí with his wax model at the Musée Grévin in Paris, 1968

Immortality and Death

In the 1970s, Dalí's artistic output dropped perceptibly, coinciding with a period when the painter's oeuvre was being extensively documented and displayed in numerous exhibitions and retrospectives, and also of course in the new museums in Cleveland, Ohio, and Figueras. During the 1950s and 1960s abstract styles had predominated, but now Dalí's works were attracting attention again and gaining the recognition and respect of a new, younger public.

His achievements as a painter were also acknowledged by the Académie des Beaux Arts in Paris, which in 1978 elected him an associate foreign member. He was proud to take part in the ceremony of admittance in May 1979 together with Gala, and in his speech of thanks, entitled *Gala, Velázquez, and the Golden Fleece*, spoke among

other things about the catastrophe theory of the French mathematician René Thom, which endeavors to describe disjointed, irregular processes with mathematical precision.

Gala died on June 10, 1982. When Dalí was brought the news of her death, he is supposed to have denied she was dead, "she will never die." Gala was buried in her castle in Púbol. Just a month later, Dalí was awarded the title of Marqués de Púbol by King Juan Carlos. In early

Salvador and Gala Dalí's house in Port Lligat, 1968

The hall of Gala's castle in Púbol, with ceiling paintings by Dalí, ca. 1972

The interior decoration of the castle followed designs by Dalí, who had given her the place. In the final years, he had come to an agreement with Gala that he would not enter it unless invited beforehand in writing.

Chair with landscape, painted for Gala's residence in Púbol, 1972–1974

The Swallowtail (Catastrophe Series), 1983
Oil on canvas
73 x 92.2 cm
Fundación Gala-Salvador Dalí, Figueras

This picture is Dalí's last oil painting and one of the few abstract works by him. It was inspired by catastrophe theory. The lines dominating the center of the picture are to be taken as a representation of swallowtails and a capital D.

1983, Dalí's health worsened, especially as he refused to take nourishment. Obsessed with the idea of being immortal, he thought that, in this way, he could sink into an artificial hibernation. In the end he had to be force-fed through a stomach tube. His condition improved only briefly, and after treatment for cardiac arrest, Dalí died on January 23, 1989. At his own request, his body was embalmed, laid in state in the museum in Figueras for a week and finally also buried there, where a small, rather plain memorial plaque indicates his grave.

Dalí in front of his last picture *The Swallowtail*, March 1983

Wearing a caftan he designed himself, the newly appointed marquis poses in front of his last oil painting. After Gala's death, the artist had retired for a while to her residence. However, following a fire in his room in which he sustained serious injuries, he moved one last time to the museum at Figueras.

Glossary of Terms

abstraction Rejection of the means of reproducing an object in a naturalistic manner, up to and including complete rejection of the representation of objects.

allegory (Gk. *allegoria*, "saying differently") Visual representation of an abstract concept or process, often in the form of a person. Unlike symbols, the connection with the object allegorized can be derived intellectually from the context.

attribute An object or action associated with a character (for example a fir garment with John the Baptist) to identify the character in a painting or sculpture.

automatism Art creation involving spontaneous writing or painting without rational control, or moral or aesthetic consideration, used as a technique by the Surrealists. Doodling is a form of automatism. See also "Automatic writing."

automatic writing Creative process based on Freudian pyschoanalysis and used by the Surrealists, who produced drawings or texts in a trance-like state, effectively allowing the subsconscious to come to the surface.

avant-garde (Fr. "vanguard") Term for artistic groups or artistic statements that are in advance of their time, go beyond what already exists and anticipate trends.

Catalonia A Mediterranean region partly in Spain and partly in France inhabited by people speaking Catalan, a Latin language related to Provençal. Spanish Catalonia, now an autonomous region again, is economically one of the most dynamic areas of modern Spain, and its chief city is Barcelona.

choreography The precise program of steps and movements by dancers during a ballet.

Classicism Style that flourished between 1750 and 1840 based on precedents of antiquity, especially ancient Greece. The style typically used clear colors and sharp linearity.

collage (Fr. "glue") Picture made up of everyday materials (such as newspaper or magazine cuttings) stuck together and possibly combined with painting or drawing.

critical paranoia A term invented by Dalí to describe a technique for producing a picture from an idea or existing model, for example an old master painting. It is based on free association of ideas, as in automatism, and the cultivation of hallucinations and delusions, but with the conscious brain still in ultimate control and able to shape the end result. In Dalí, it often meant placing familiar material in

dreamlike settings. See page 32.

Cubism Style invented by Picasso and Braque around 1907 in which objects are no longer painted according to the optical impression they give but are broken up into geometrical shapes. A distinction is made between Analytical Cubism (up to ca. 1911) and Synthetic Cubism (1912 to mid-1920s).

Dadaism A style developed during World War I. The Dadaists rebelled against traditional artistic values with deliberate meaninglessness and new forms of "art" called "anti-art", including photo-montage, collage and nonsense poems.

Fauvism (Fr: *fauves* "wild animals") Loosely associated group of artists that developed around Matisse in 1905 in opposition to the Impressionists' dissection of color. They used pure, unbroken colors in their pictures, ignoring the accuracy of depiction. The most important representative of the style, which gave way to Cubism in 1907, was Henri Matisse.

Futurism Italian style created by the writer T. Marinetti in 1909 with the Futurist Manifesto. Markedly anti-academic, the chief aim was to capture in art the achievements of technology, particularly the sensation of speed.

golden section A supposedly divinely established proportion in which straight lines and rectangles are divided in a relationship of 1:1.4, which is also the proportion of the larger part to the whole. This proportional relationship is felt to be particularly harmonious. The golden section was used in antiquity, and reintroduced in the Renaissance.

gouache Painting medium that was water-based paints that, unlike watercolors, are not transparent but remain opaque when they dry. By adding binders and opaque white, a pastel color effect is produced with a brittle surface.

history painting Representation of historical events and mythological, Biblical, and literary themes in either a realistic or idealized form. Up to the end of the 19th century, history painting counted as the supreme genre of painting, followed by portraits and the inferior genres of genre painting and still lifes.

hologram Two-dimensional picture which can produce a three-dimensional illusion with a special laser technique. Holography has been used in art ever since the 1960s.

Impressionism French art style developed around 1870 which aimed to depict

outdoor objects in their momentary appearance in the given natural lighting, based on subjective impressions gained direct from nature. Impressionists therefore painted to a large extent in the open air. Technically, the style breaks up the appearance of the subject into small patches of color that recombine to a whole in the viewer's eye. Colors are bright, and the pictorial section often seems accidental. Preferred subjects were landscapes and scenes of urban life.

levitation Apparent suspension of gravity, so that objects no longer rest on the ground. The concept also covers the spiritual appearance of a saint floating free in space.

libretto The text of an opera or operetta.

logarithm Term for a number with which the exponent of an equation with an unknown quantity can be ascertained by means of a defined mathematical process.

metamorphosis Change from one form to another.

metaphor Where the meaning of something is expressed in image form.

metaphysics Philosophical discipline which is concernd with principles beyond the world of the senses.

mysticism Form of faith that seeks union with God

through contemplation and spiritual devotion.

mythology Legends of gods and heroes. In Classical times, mythology was a popular subject in art. Rediscovered in the Renaissance, mythology became an important source for many pictorial topics in western art.

New Objectivity/Neue Sachlichkeit German style from ca. 1923 to 1933 founded as a reaction to the then current abstract, subjective styles such as Expressionism. The result was a sober, isolated, and still-life type style that drew subject matter from visible objects. Its chief proponents were Dix and Grosz.

obelisk (Gk. "roasting spit") A rectangular stone column, narrowing towards the top, with a pyramid-shaped point. Originally a feature of Egyptian art, its shape was taken up once more by the Renaissance.

oeuvre The total output of an artist.

phallus Greek/Latin term for the penis, used mainly as a visual symbol of fertility and potency.

pop art 1960s style in the USA and UK that created a new approach based on consumerism and used existing objects such as newspaper cuttings, comic books, advertising brochures, film clips, and brand articles.

psychoanalysis A method for investigating psychic disorders developed by Sigmund Freud around 1900. Freud's basic assumption was that psychic disorders derive from the repression of mostly early childhood experiences. Psychoanalytical theory was the basis of Surrealism.

puzzle picture Picture in which several different motifs can be found.

ready-made Term introduced by Marcel Duchamp in 1913 for industrially made found objects, for example a bottle rack or urinal, which he declared works of art without any (or with minimal) further treatment.

realism Style of the second half of the 19th century, established as a reaction to academic taste for idealized subject matter. Realism meant not only a faithful portrayal of objects but also, more profoundly, the depiction of everyday reality.

Renaissance (Fr. "rebirth") Important period of art history commencing around 1420 in Italy that took the art and philosophy of antiquity as its model. Marks a shift from the medieval God-centered to the modern man-centered world.

Romanticism Art style developed in the early 19th century that set feeling as

the foremost criterion. Typical pictures are moody landscapes and scenes from medieval legends and history.

Salon painting A late-19th century, usually denigratory term referring to academic traditions and styles considered suitable for bourgeois tastes and exhibition at the official annual French *Salons*.

Surrealism Style of literature and painting developed from 1924 with the publication of André Breton's *Surrealist Manifesto*. Using the free association of ideas, psycho-analytical investigation of the subconscious and dreams, Surrealism aimed to give expression to the irrational and uncontrollable.

trompe l'œil (Fr. "deceive the eye") A way of painting so naturalistically that the object painted seems real.

volute Ornamental scroll on a classical capital.

Index

Index of Works

Index of Names

Acknowledgments

The publishers would like to thank all the museums, photolibraries and photographers for allowing reproduction and for their friendly assistance in the publication of this book.

Photographs:
Cecil Beaton: 67 t
Pierre Boulat: 85 b
Ana-Maria Dalí: 16 b
Robert Descharnes: 39 t, 64 b, 65 l, 71 tr, 75, 83 t, 85 t, 86 t, 89 tr, 90 t/br/bl, 91 b
André Micheau: 67 b
Man Ray: 2
Eric Schaal: 37 tr, 66 r/l
Weegee: 59 tr

© Archiv für Kunst und Geschichte, Berlin: 7 tl, 47 tr (Cameraphoto Epoche), 59 tr, 60 b, 64 b, 67 t/b, 68 l, 69 r, 74 b (Cameraphoto Epoche),

76 b (photo Erich Lessing), 89 bl (photo Justus Göpel)

© Pierre Boulat/Cosmos/Focus, Hamburg: 85 b

© Bridgman Art Library, London: 52 b

© Collections Musée nationale d'Art Moderne/Cci/Centre Georges Pompidou, Paris: 20 tr/br/l (photos Jean-Michel Bouhours)

© Descharnes & Descharnes, Paris: 4 tr/tl/br/bl, 5 tr/tl/br/bl, 6, 7 tr/b, 8 t/b, 9 r/l, 10 t/b, 11, 12 t/b, 13, 14, 15 tr/b, 16 t/b, 17, 18 t/b, 19 r/l, 21, 22, 23 tr/b, 24 t/b, 25, 26 t/b, 27, 28, 29 t/b, 30 t/b, 31 t/b, 32 t/b, 33, 35 t/b, 36, 37 b, 38 b, 39 t/b, 40, 41 t/b, 42 t/b, 43 t/cr/cl/br/bl, 44 t/br/bl, 45, 46, 47b, 48 tr/tl, 49, 50

t/c/b, 51 t/b, 52 t, 53, 54 b, 55, 56 t/b, 57, 58, 59 b, 60 t, 61, 62, 63 tr/tl/b, 65 r/l, 68 r, 69 l, 70, 71 tr/b, 72 t/b, 73, 74 tr/cr, 75, 76 t, 77 t, 78 t/b, 79, 80 b, 81 t/b, 82, 83 tr/b, 84, 85 t, 86 t/b, 87, 89 tr, 90 t/br/bl, 91 t/b

© Eric Schaal/Weidle Verlag, Bonn: 37 tr, 66 r/l

© Hulton Getty Picture Collection, London: 15 tl, 23 tl, 37 tl, 47 tl, 54 t, 59 tl, 71 tl, 83 tl, 88, 89 br

© Man Ray Trust / ADAGP / Telimage - 1999, Paris: 2

© Scala, Florence: 38 b

All other illustrations are taken from the institutions named in the captions or the publishers' archives. The publisher has made every effort to obtain and compensate copyright

permission for all the works shown in the illustrations. Should nonetheless any other legitimate claims subsist, the persons concerned are asked to get in touch with the publisher.

Key
r = right l = left
t = top b = bottom
c = center

© 1999 Könemann Verlagsgesellschaft mbH
Bonner Strasse 126, D-50968 Cologne

Editor: Peter Delius
Art director: Peter Feierabend
Series concept: Ludwig Könemann
Cover design: Claudio Martinez
Design and layout: Delius Producing Berlin
Picture research: Jens Tewes, Florence Baret
Reproductions: C. D. N. Verona

Original title: Salvador Dalí

© 2000 for the English edition: Könemann Verlagsgesellschaft mbH

Translation from German: Paul Aston in association with Goodfellow & Egan
Editing: Susan James in association with Goodfellow & Egan
Typesetting: Goodfellow & Egan, Cambridge
Project management: Jackie Dobbyne for Goodfellow & Egan Publishing
Management, Cambridge, UK
Production: Ursula Schümer
Project coordination: Nadja Bremse
Printing and binding: Leo Paper Products Ltd., Hong Kong
Printed in China

ISBN 3-8290-2934-9

10 9 8 7 6 5 4 3

Front cover:
**Face of Mae West
(can be used as Surrealist
apartment),** 1934–1935
Gouache on newspaper
31 x 17 cm
Art Institute, Chicago

Illustration p. 2:
Salvador Dalí, 1929–1931
Photo: Man Ray

Back cover:
Salvador Dalí, 1959
Photo: Robert Descharnes